IMAGES
*of America*

# KALAMAZOO
## MICHIGAN

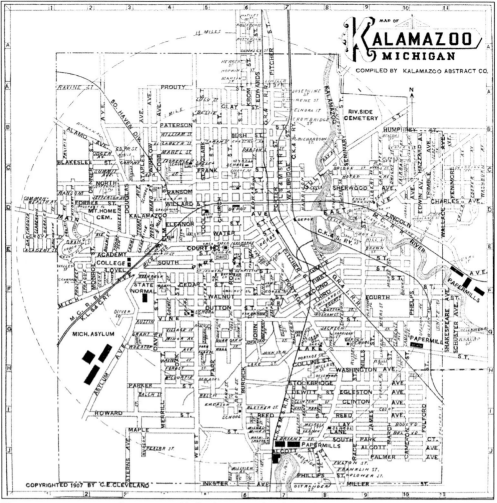

**KALAMAZOO: 1907.** This map, published in 1907 by the Kalamazoo Abstract Company, shows not only the arrangement of streets but the location of important institutions and businesses. Note the asylum, schools, and papermills.

IMAGES
*of America*

# KALAMAZOO
## MICHIGAN

David Kohrman

ARCADIA
PUBLISHING

Published by Arcadia Publishing
Charleston, South Carolina

Printed in the United States of America

Library of Congress Catalog Card Number: 2002113748

For all general information contact Arcadia Publishing at:
Telephone 843-853-2070
Fax 843-853-0044
E-mail sales@arcadiapublishing.com
For customer service and orders:
Toll-Free 1-888-313-2665

Visit us on the Internet at www.arcadiapublishing.com

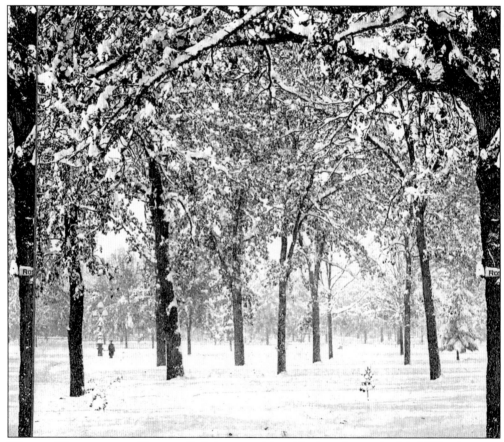

**WINTER WONDERLAND.** Bronson Park is covered in a blanket of snow in this 1870s view.

# CONTENTS

# ACKNOWLEDGMENTS

Without the help of many individuals, this project would never have been possible. I owe them a great many thanks. Sharon Carlson and the staff of the Western Michigan University Archives and Regional History Collections helped me find and use many of the images in this volume. I must also thank my editor, Maura Brown of Arcadia Publishing, as well as the faculty and my fellow students of Western Michigan University's History Department. Finally thanks to my friends, family, and co-workers for providing the support needed to get the job done.

# INTRODUCTION

Kalamazoo, Michigan, is a small Midwestern city located halfway between Detroit and Chicago. It is perhaps due to this location that Kalamazoo has had the success it has experienced since its first settlement in 1829. The city grew rapidly throughout the 19th century and into the 20th. Besides claiming a wonderful built environment, Kalamazoo also became home to a number of industries, colleges, and a state hospital. Due in large part to these developments, the story of Kalamazoo is both an interesting and important one. A great deal of American history and society is reflected in it.

The photographs found in this volume were largely drawn from the Archives and Regional History Collections at Western Michigan University. Other images come from private collections. The pictures fall in a date range between 1860 and 1960 and are examples of many photographic types. In addition to photographic prints of all sizes, the images in this volume also represent stereopticon cards. Made popular in the late 19th century, these cards feature double images that, when seen through a special view, produce a 3-D effect.

Picture postcards were at their peak between 1900 and 1950. During this time some publishers produced "real photo" postcards, which are photographic prints in a postcard size. These often feature rare and detailed views of city scenes and locations. Lastly, the Ward Morgan Collection at the WMU Archives and Regional History Collections is a wonderful resource of negatives produced by a commercial photographer between 1930 and 1970.

The following collection of photographs does not attempt to provide a complete history of Kalamazoo, as this could not be done. Rather it is intended to showcase some of the important features of Kalamazoo's past. Unfortunately, not everything could be covered. Chapters One and Two review Kalamazoo's experience in the 19th and 20th centuries. The following three chapters focus in detail on the city's industry, the state hospital, and the many colleges. I have made every effort to use images that have never before been published or have not been readily accessible until now. My personal interest has always been in the built environment and institutions, a fact that is likely reflected in the photographs. It is my hope that the images that follow increase your desire to learn more about the wonderful city I proudly call home.

# *One*

# THE 19TH CENTURY

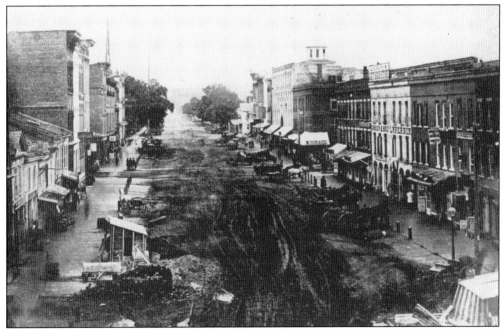

**MAIN STREET.** This photograph from 1861 is the earliest photograph of Main Street, today's Michigan Avenue, known to exist. And thus it is with it that this volume begins. By this time, Kalamazoo was already almost 30 years old. Brick buildings make up most of the street wall, though the street itself appears to not yet be paved. The tall building with the cupola is the Burdick Hotel, the site of today's Radisson Plaza Hotel. The clump of trees on the left indicates the location of the courthouse and Bronson Park.

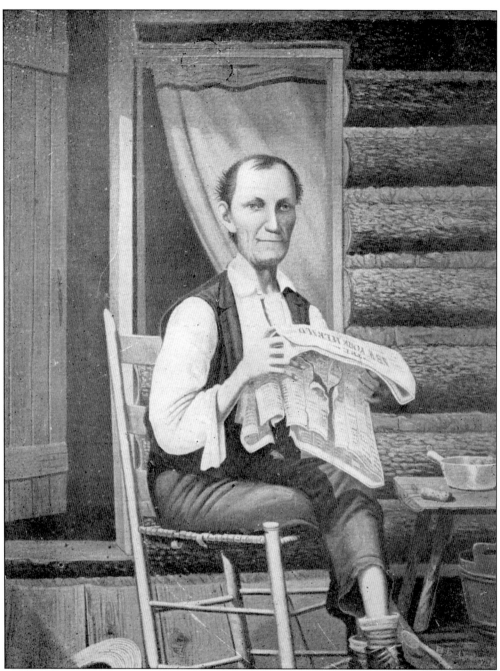

**TITUS BRONSON.** Bronson was Kalamazoo's first settler and its founder. In 1829 he built a house on the current corner of Water and Church Streets and laid out the village. This layout became the basis for much of Kalamazoo's development. He included a park, sites for a school, churches, and a courthouse. He named the new settlement after himself: Bronson, Michigan. The name did not stick, and was changed to Kalamazoo in 1836. Titus Bronson left soon after. This painting dates from 1879.

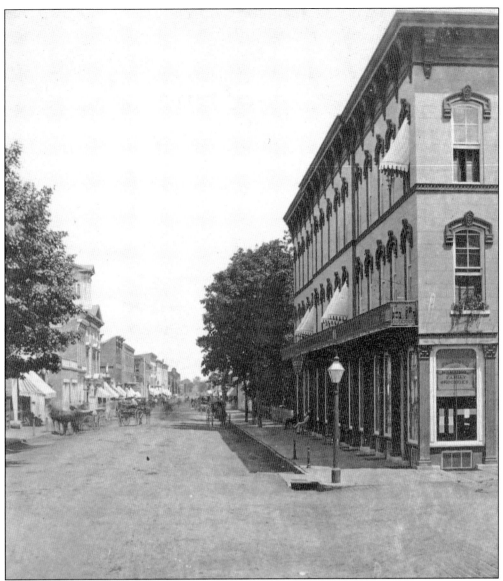

SOUTH BURDICK STREET. Jumping ahead we see Burdick Street as viewed from South Street around 1870. By the turn of the century, Burdick would establish itself as the primary retail center for the city and surrounding area. However, at this point, much of the street still appears in need of development. Clumps of trees have yet to make way for business blocks. The large building on the right is the International Hotel, half of which survives today. The building on the left with the cupola is Corporation Hall, which served as city hall and as both the fire and police stations.

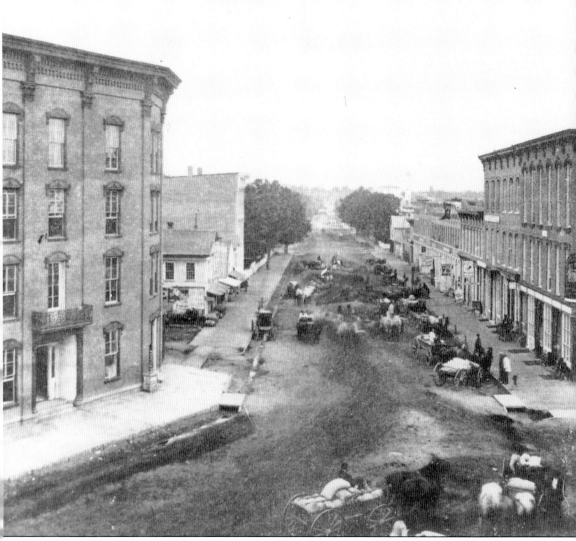

EAST MAIN STREET. This photograph of East Main Street, also taken around 1870, reveals that it was also a developing commercial strip. Old wooden buildings and trees are gradually giving way to tall brick structures, many of which survive today. (Western Michigan University Archives and Regional History Collections.)

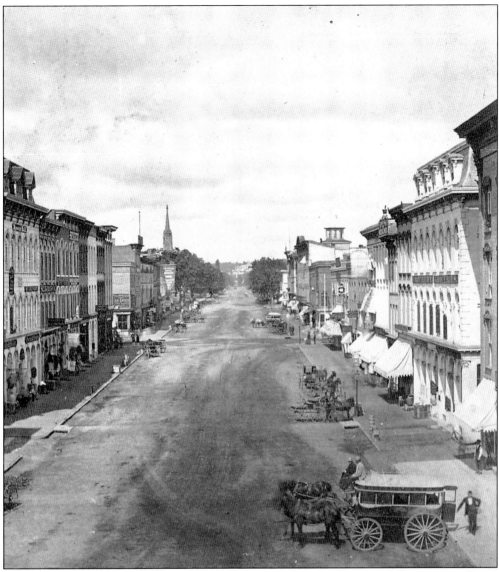

**MAIN STREET LOOKING WEST.** Turning around, Main Street west of the Portage Street intersection was fully developed by the time this mid-1870s photograph was taken. Elegant Italianate storefronts with their arched windows and heavy cornices speak of the popular tastes of the time and give the still-young town an old established look. Streetcar tracks have yet to be installed.

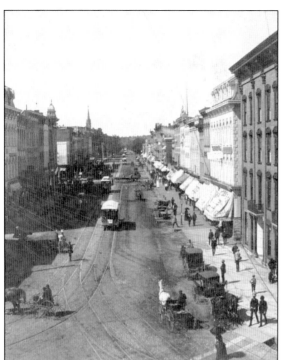

**MAIN STREET.** Similar to the previous picture, this view of Main Street dates from after 1885, as seen by the presence of streetcars and the courthouse cupola in the distant left. The construction of the first horse-drawn railway began in 1884. Another modern feature in this photograph is elevated telephone lines.

**THE BURDICK BLOCK.** The block bound by Main, Rose, Water, and Burdick Streets was known as the Burdick block for much of Kalamazoo's history. It was so named for its primary landmark, the Burdick Hotel. This early 1880s view shows the storefront buildings along the Main Street side of the block, from the intersection with Rose Street.

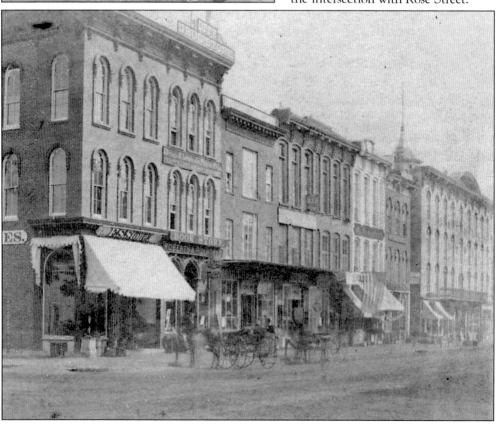

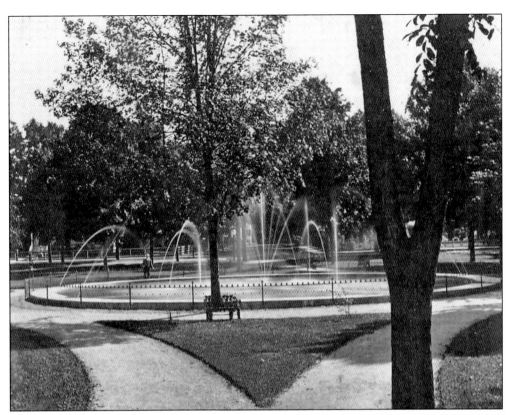

**BRONSON PARK.** It can be claimed that Bronson Park is the heart of Kalamazoo. This is just as true today as it was when these 1880s photographs were taken. Situated on two blocks of the southwest side of downtown, the park is the traditional location for churches and other public buildings.

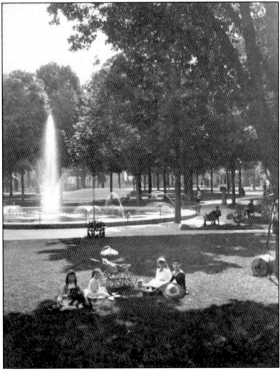

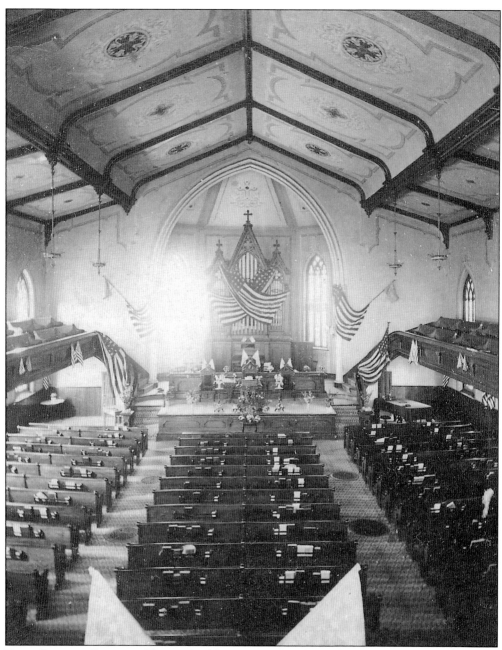

**FIRST BAPTIST CHURCH.** The city's oldest extant church building, First Baptist was built in 1853 as one of the churches along Bronson Park. This view was taken after an 1871 renovation and possibly dates from 1876 as the flags suggest. The spacious and ornate interior was typical of the city's 19th-century churches. In addition to serving religious purposes, churches functioned as auditoriums and meeting halls. The city placed a special alarm bell atop First Baptist's tower. (First Baptist Church Library.)

**THE COURTHOUSE.** In addition to churches, Bronson Park has long been the location for the Kalamazoo County Courthouse. The version seen here opened in 1885. Alas, the elaborate domed building, crowned with a statue of Justice, had chronic space shortages. In 1937 it gave way to the current facility.

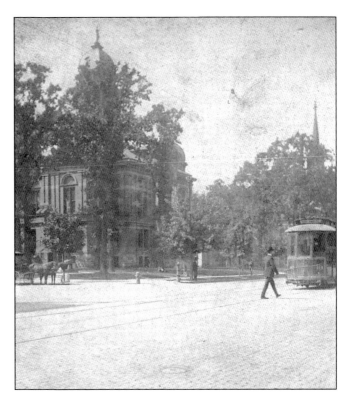

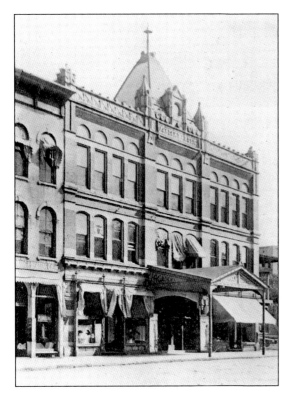

**ACADEMY OF MUSIC.** In 1882 a public building of another sort decorated the park for the first time. The Academy of Music on Rose Street provided Kalamazoo with a proper opera house. At a cost of more than $65,000, the building was lavishly decked out with silk, gas lighting, and ornate woodwork. The building was the product of a Chicago architect named Adler, who was paired with the soon-to-be-famous Louis Sullivan as a draftsman.

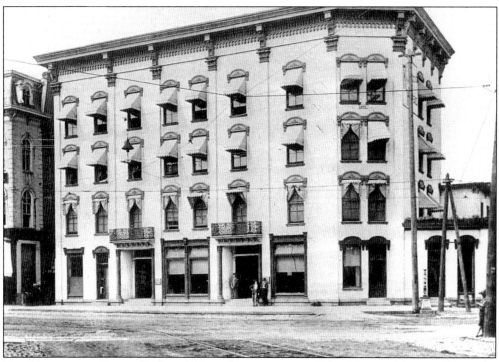

**THE KALAMAZOO HOUSE.** Built in 1861 at the intersection of East Main and Portage Street, the Kalamazoo House was an important 19th-century institution. It replaced an earlier wood-framed building that was Kalamazoo's first hotel. After 45 years of service, this building was pulled down in 1906. (Western Michigan University Archives and Regional History Collections.)

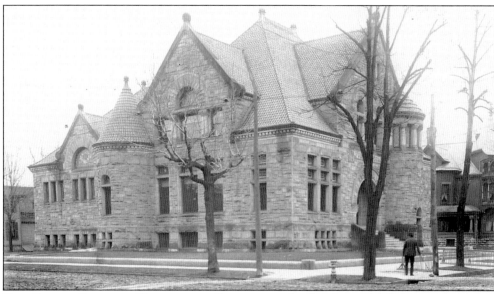

**THE PUBLIC LIBRARY.** This massive Romanesque landmark served Kalamazoo's readers between 1893 and 1958. Built with a donation of $50,000 from Dr. Edwin Van Deusen and his wife, the building soon suffered from overcrowding as Kalamazoo itself grew. (Western Michigan University Archives and Regional History Collections.)

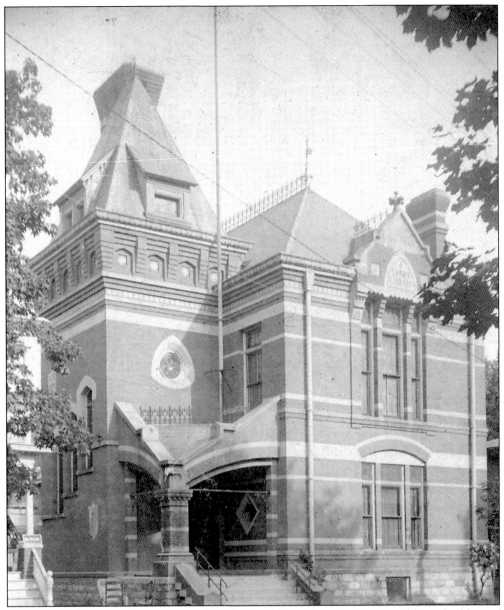

**THE LADIES LIBRARY ASSOCIATION.** The Ladies Library Association was a library building of a different sort. Built in a Victorian Gothic style, it opened in 1878 as the first building built for and by a woman's organization. The association had been founded in 1852 with the purpose of discussing literature and holding lectures and concerts. Remarkably, the building has been altered only slightly. Restored in 1975, it remains a Kalamazoo landmark.

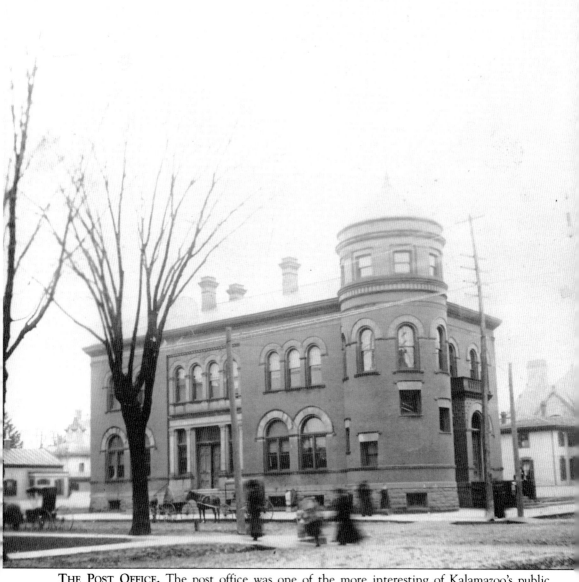

**THE POST OFFICE.** The post office was one of the more interesting of Kalamazoo's public buildings. The red brick Romanesque building featured a round tower, a distinctive landmark for the corner of Burdick and South Streets. This 1890s photo shows the building shortly after its completion in 1892. Soon overcrowded, it was expanded in 1904. However, it could not keep up with the growth of the town and was replaced in 1939. The old landmark was removed for a parking lot in 1940. (Western Michigan University Archives and Regional History Collections.)

**GILMORE'S.** A Kalamazoo institution for nearly a century opened at this site in 1899. Gilmore's would become Kalamazoo's leading department store for much of the 20th century. Expansions in 1908 and 1976 only made its presence even stronger.

However, as the 20th century drew to a close, Gilmore's began to struggle. Alterations to the downtown Kalamazoo Mall would not prevent its closing in August of 1998. The original building, seen here, has survived.

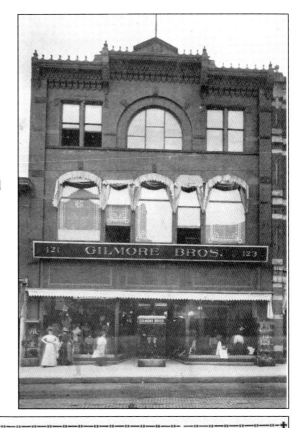

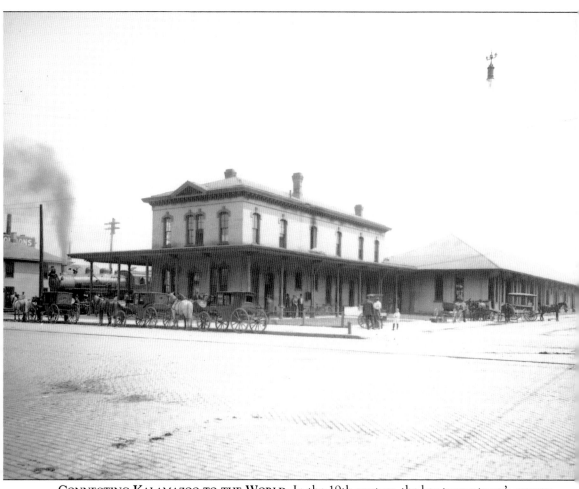

**CONNECTING KALAMAZOO TO THE WORLD.** In the 19th century, the key to any town's success was the presence of a railroad. Kalamazoo's fortunate geographic location insured it would be well-connected to the world. The Grand Rapids & Indiana Depot, shown here, was the city's main north-south gateway. The GR&I first arrived to Kalamazoo in 1870, when it built a wood-framed depot. After a fire destroyed the original station, this brick depot opened in 1875. (Western Michigan University Archives and Regional History Collections.)

**THE MICHIGAN CENTRAL DEPOT.** The Michigan Central Railroad connected Kalamazoo to Detroit and Chicago. The building pictured on the left was its second depot to service Kalamazoo. Located on North Burdick Street, the 1853 wood frame building was a supreme example of the Gothic Revival style. (Western Michigan University Archives and Regional History Collections.)

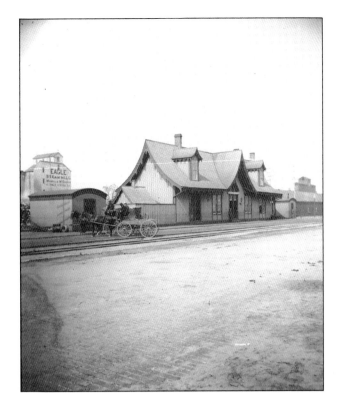

**THE MICHIGAN CENTRAL DEPOT.** As Kalamazoo grew, the old facility would no longer suffice and in 1887, it was replaced by the stone structure seen below. The new depot, a red castle in the Romanesque style, would serve as Kalamazoo's principle east-west connection until the advent of automobiles. It serves today as the local Amtrak and bus station. (Western Michigan University Archives and Regional History Collections.)

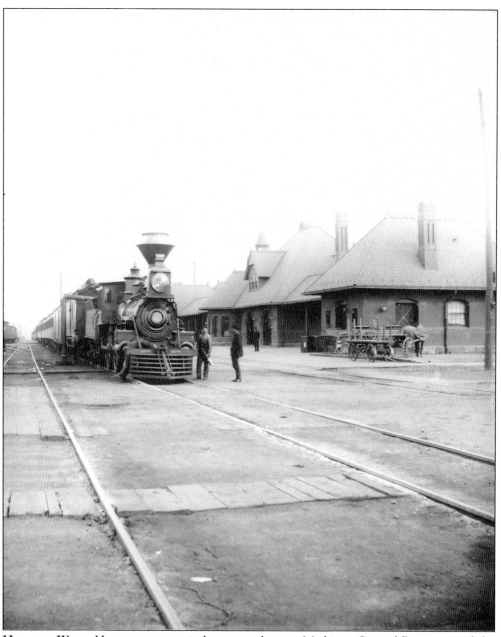

**HEADING WEST.** Here we see a typical scene at the new Michigan Central Depot around the end of the 19th century. By the 1890s, 45 passenger trains arrived in Kalamazoo on a daily basis. (Western Michigan University Archives and Regional History Collections.)

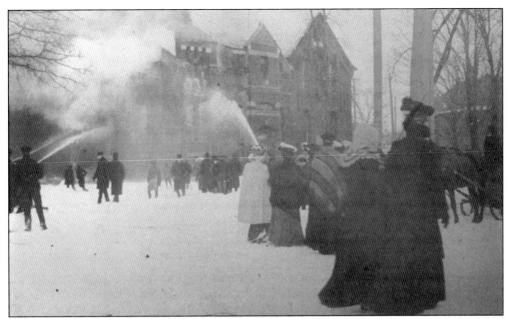

HIGH SCHOOL FIRE. On a February morning in 1897, Kalamazoo awoke to find the high school ablaze. This remarkable photo shows the fire department attempting to save the building as a crowd gathers. Unfortunately, the school had to be demolished and replaced. (Western Michigan University Archives and Regional History Collections.)

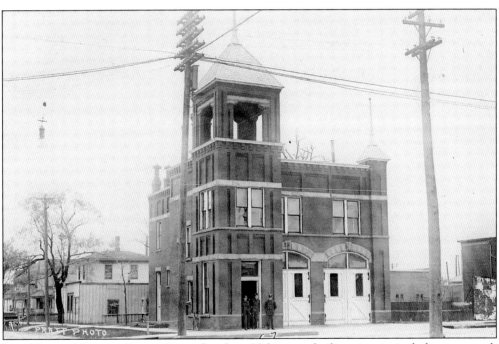

FIRE HOUSE NUMBER FOUR. To combat fires, Kalamazoo built an increasingly large network of stations around town. Fire House Number Four, shown here, was built in 1887 on North Burdick Street to service the growing north side of town. No longer a fire house, the building survives today.

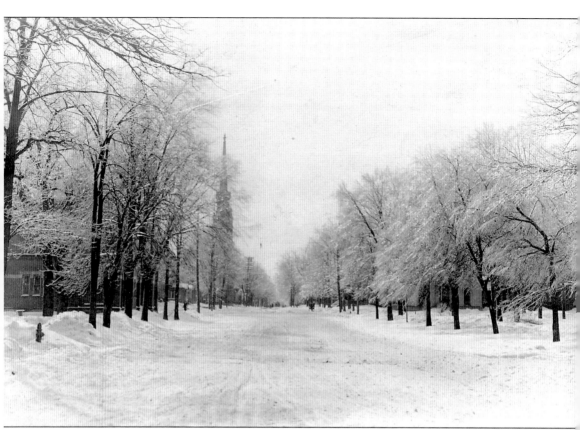

**WINTER WONDERLAND.** Michigan has often been called a "winter wonderland." This photograph looking south down Rose Street shows why. At the time of this photo, driving automobiles in these conditions has yet to develop into a problem. The steeple of the First Methodist Church is visible in the distance. (Western Michigan University Archives and Regional History Collections.)

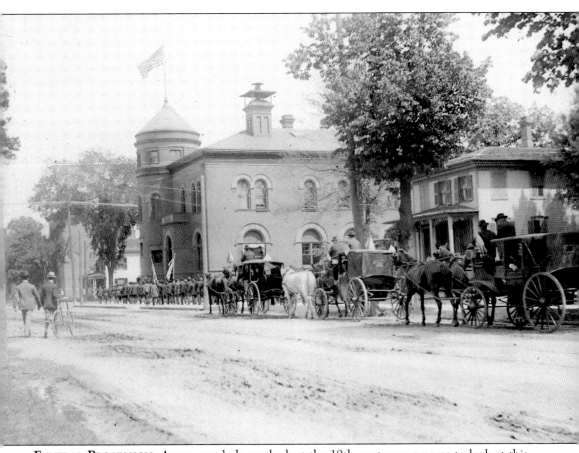

FUNERAL PROCESSION. As we conclude our look at the 19th century, we pause to look at this 1890s funeral procession. The picture is identified as the funeral procession of Frederick W. Curtenius, a Civil War veteran, former village president, and noted orator. However, Curtenius died in 1883, before the post office seen here was built. (Western Michigan University Archives and Regional History Collections.)

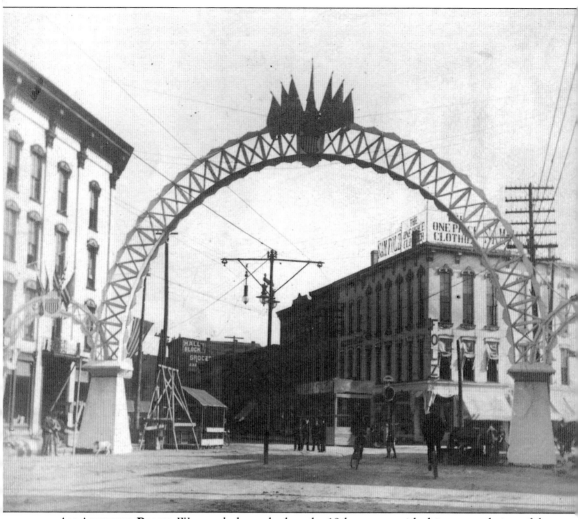

**AN ARCH FOR PEACE.** We conclude our look at the 19th century with this eastward view of the arch erected for the October 7, 1898 Peace Jubilee Parade in honor of General William Rufus Shafter. Shafter, of Galesburg, lead the American forces in Cuba at the Battle of Santiago. Unfortunately, the 20th century would not be as peaceful as anyone had hoped. Samuel Folz's clothing store is visible in the background. (Western Michigan University Archives and Regional History Collections.)

# *Two*

# THE 20TH CENTURY

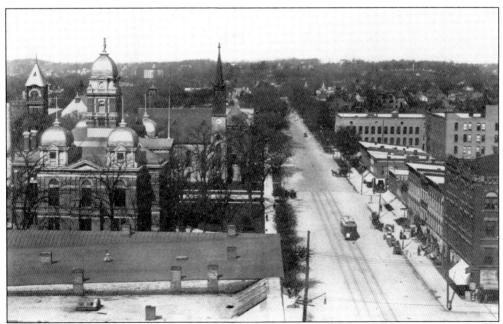

LOOKING WEST FROM THE KALAMAZOO NATIONAL BANK BUILDING. Kalamazoo would blossom like never before in the 20th century. Among other things, new modern symbols such as skyscrapers began to appear. This view looking west down Main Street is from the roof of the first such building, the Kalamazoo National Bank Building. Bronson Park and the courthouse are on the left.

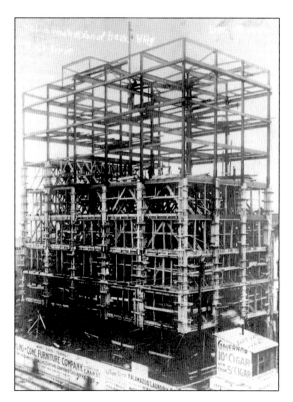

**RAISING THE STEEL.** Although only a modest eight stories, the new skyscraper made Kalamazooans proud. Several photographs of its construction were taken and mailed as postcards to friends and relatives around the world. This view, taken in December of 1906, shows the completed frame towering over the older storefronts.

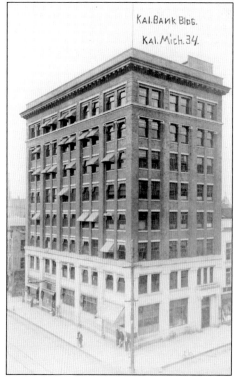

**THE KALAMAZOO NATIONAL BANK BUILDING.** This is how the Kalamazoo National Bank would appear when completed. Its eight stories contained a bank, cigar store, and various offices. In the mid-1960s, a series of renovations would alter its exterior appearance somewhat. But the building survives today, known to most as the Kalamazoo Building.

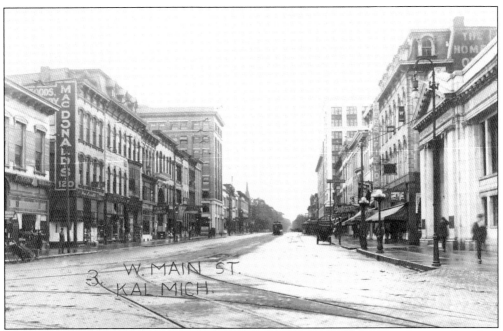

**MAIN STREET C. 1913.** Downtown appears rather dead and wet in this photograph, taken sometime around 1913. The landscape is considerably different with the presence of the new skyscrapers, the Kalamazoo National Bank Building and the Hanselman Building across the street. Completed in 1913, the Hanselman Building was the tallest building in the city until 1929.

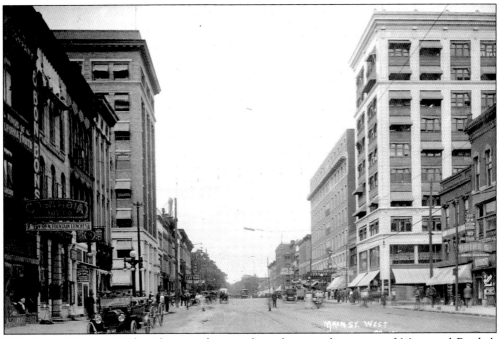

**MAIN AND BURDICK.** This photograph was taken closer to the corner of Main and Burdick Streets and provides an interesting look at the area's businesses.

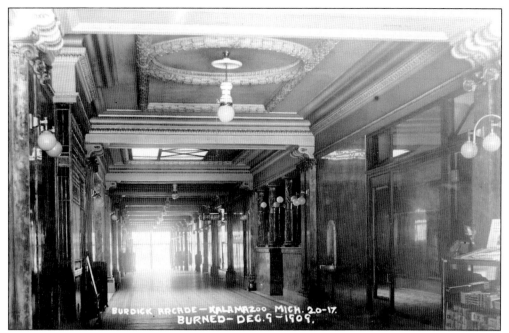

**THE BURDICK ARCADE.** No one event in the early 20th century so transformed downtown as the Burdick fire. As indicated in this photo postcard, during the evening of December 9, 1909, much of the Burdick block was destroyed. Included among the lost was the recently renovated Burdick Hotel. Its interior shopping arcade is shown here.

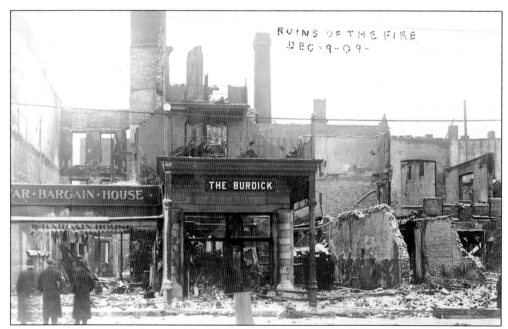

**IMPRESSIVE RUINS.** The fire started at the Star Bargain House, adjacent to the Burdick Hotel. Unfortunately, the fire quickly spread until the hotel itself was a total loss. This photograph, one of many taken the day after the blaze, shows the incredible destruction that resulted. The proud hotel had been reduced to a heap of rubble overnight.

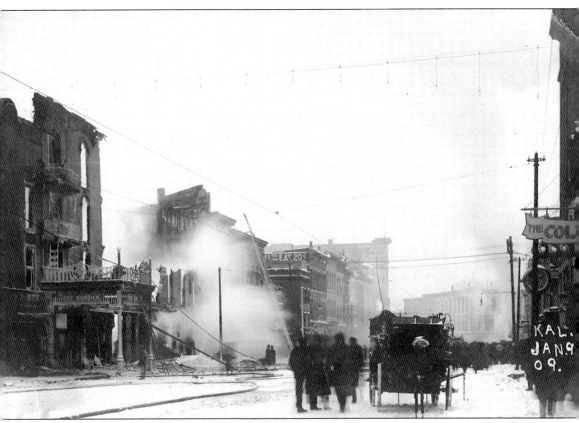

OUT OF CONTROL. The fire was too much for the Kalamazoo Fire Department to handle, and thus they sought the help of departments from neighboring cities. Water from the State Hospital's water tower had to be used by stringing hoses along the distance. Yet by the next morning, only smoldering ruins remained.

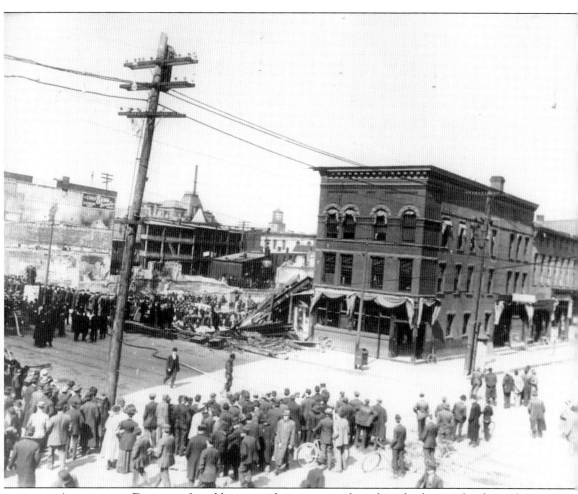

**ADDITIONAL DAMAGE.** In addition to the structures lost directly due to the fire, adjacent buildings were destabilized. In the days afterwards, some proceeded to collapse, as pictured here. Such destruction set the stage for a remarkable rebuilding of a large section of the central city. (Western Michigan University Archives and Regional History Collections.)

THE "NEW" BURDICK HOTEL. Within two years of the destruction of its predecessor, a new and expanded Burdick Hotel opened on the same site. President Taft was invited to Kalamazoo, primarily to open the new hotel. For 60 years, this Burdick would serve as the social center of the city. The skeletal frame of the Hanselman Building can be seen going up next door.

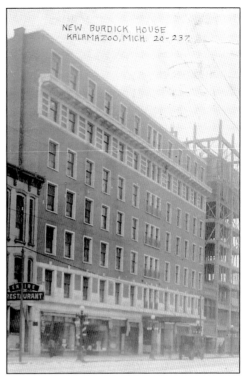

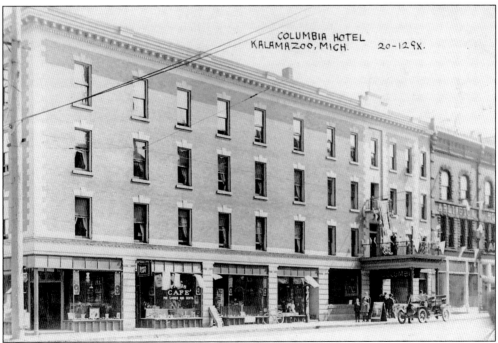

THE COLUMBIA HOTEL. This 150-room establishment on East Main would rival the Burdick for many years. Slowly built upon from a run-down predecessor, by the 1920s the Columbia had become a first rate hotel. Its fate has been better than most of its competitors. It serves as an office building today.

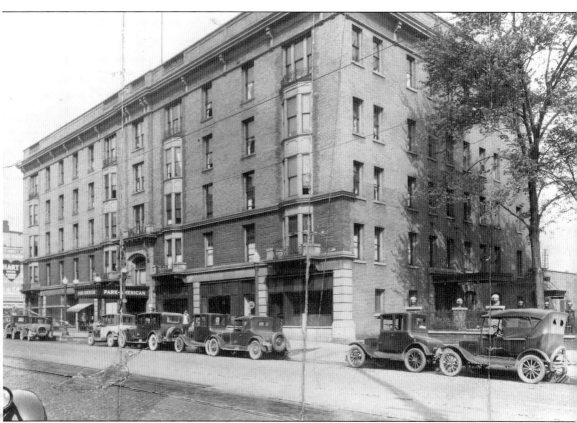

**THE PARK-AMERICAN HOTEL.** This hotel on East Main Street was another of the Burdick's primary rivals. Introduced as the American Hotel in 1869 by Fred Hotop, by 1914 it was a fully modern facility. The Park-American was particularly noted for its dining. In this 1920s photo, we see the hotel and the adjacent park from which the name derived. Later known as the Harris, the old landmark closed in 1968 and was razed soon afterward. (Western Michigan University Archives and Regional History Collections.)

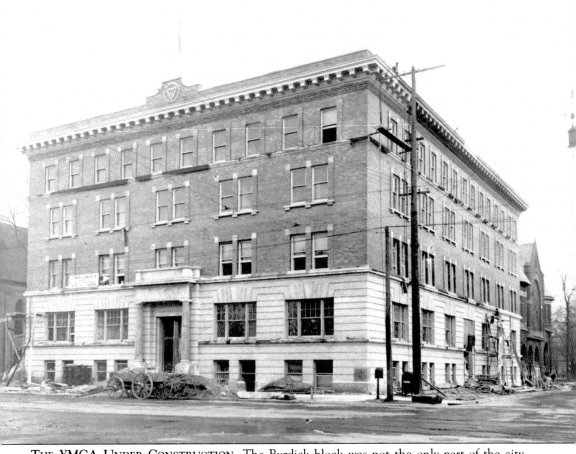

**THE YMCA UNDER CONSTRUCTION.** The Burdick block was not the only part of the city to require rebuilding after a second fire occurred in 1911. The YMCA had been completely leveled. When President Taft arrived to dedicate the Burdick Hotel, he was also on hand to dedicate construction of the new YMCA, seen here nearing its completion. The YMCA lasted at this West Main location until 1970.

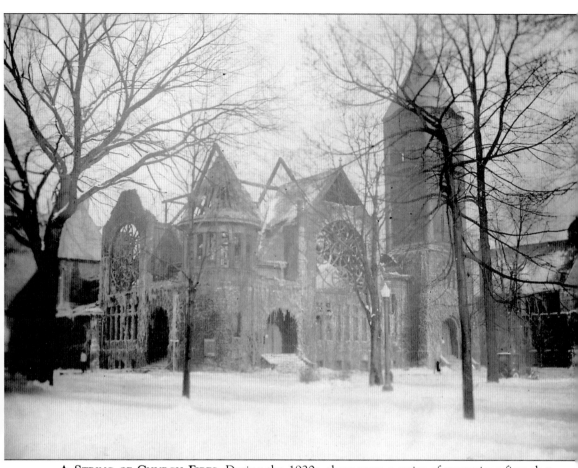

**A STRING OF CHURCH FIRES.** During the 1920s, there were a series of mysterious fires that wiped out many of the city's 19th-century sanctuaries. The fire shown here destroyed the First Congregationalist Church in 1927. The outcome of many of these fires was the construction of the churches we know today. (Western Michigan University Archives and Regional History Collections.)

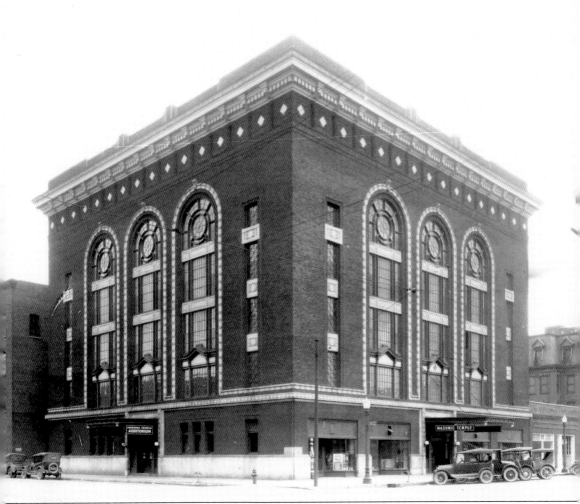

**MASONIC TEMPLE.** The Freemasons were a powerful group when they built this headquarters on Rose Street in 1913. The building's construction was the occasion of a parade and ritualistic laying of the cornerstone. Beyond the unique façade lay three auditoriums, stores, and office space. Closed in the early 1970s, the building was brought back to life in the 1980s as Rose Street Market. This picture dates from the 1920s. (Western Michigan University Archives and Regional History Collections.)

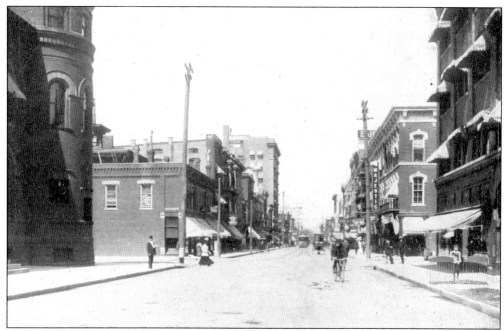

**BURDICK STREET.** Burdick Street has grown since we last looked at in on page 11. There are considerably more buildings and fewer trees. The Kalamazoo National Bank Building rises in the background and the tower of the post office anchors the left side. A sign indicates the location of the Majestic Theater.

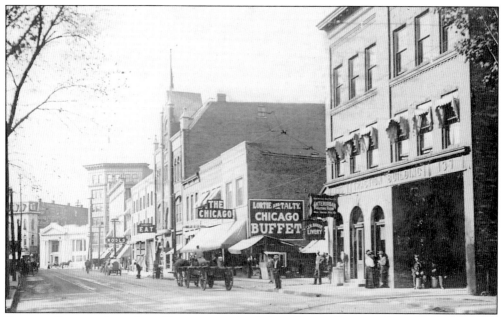

**PORTAGE STREET.** A number of businesses existed along Portage Street in the early 20th century. Among them was an interurban depot. Interurbans were large streetcars that operated between nearby cities and towns. The tall building with the unique roofline is the Auditorium Building.

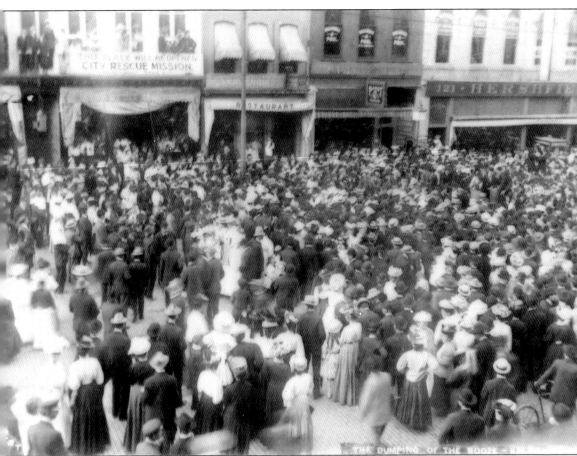

**DUMPING THE BOOZE.** A unique scene took place one afternoon in 1907. The City Rescue Mission had purchased the former Oxford Saloon at 115 East Main Street as well as several hundred gallons of whisky. As a dedication of the property to its new use, mission superintendent W.S. Calgrove took an axe to the whisky, dumping it into the drains. Afterwards Calgrove gave a sermon atop an empty beer keg and the crowd sang hymns. Kalamazoo went dry in 1915. (Western Michigan University Archives and Regional History Collections.)

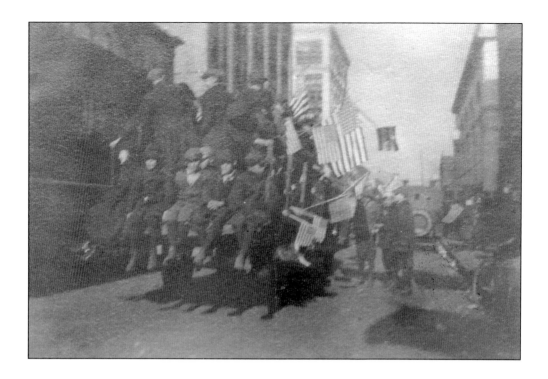

**ARMISTICE DAY.** A public demonstration of another sort would take place 11 years later. These photographs show the city's reaction on Armistice Day, November 11, 1918. Displaying American and British flags, celebrants drive down Burdick towards the train station in trucks. (Western Michigan University Archives and Regional History Collections.)

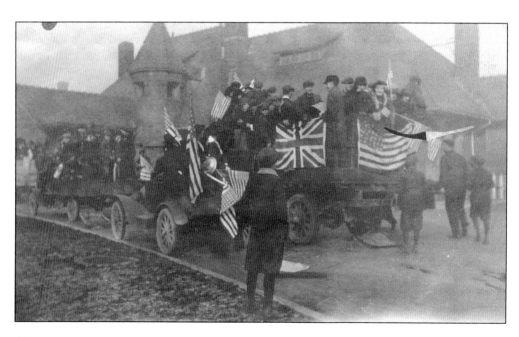

**PARADES.** Not all processions were spontaneous. In the top photo, we see the 1928 Memorial Day parade down West Main. Crowds liked the sidewalks much as they do today; however, during this parade, World War I was still fresh on peoples' minds. The lower photo shows the Maccabees parading down East Main in 1910. For them, World War I had yet to take place. (Western Michigan University Archives and Regional History Collections.)

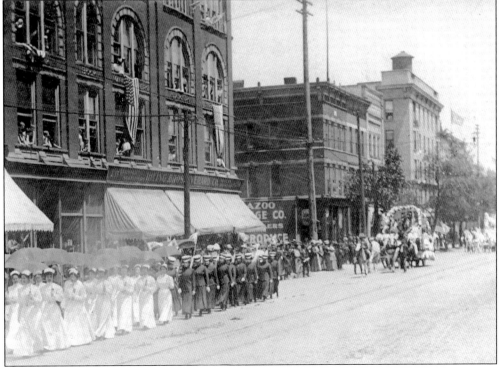

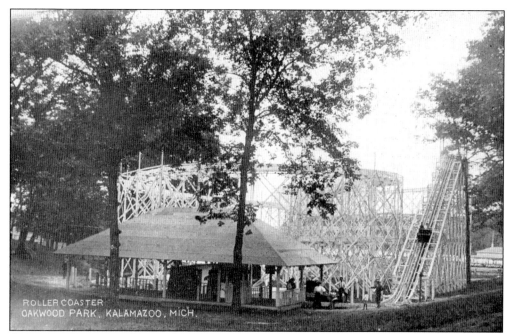

**OAKWOOD PARK.** Besides parades, Kalamazooans of the early 20th century enjoyed Oakwood Park on Woods Lake. First opened in 1893, the park enjoyed steady patronage from the streetcar lines that connected it to the city. Various entertainments included a dance hall, swimming, boating, roller-skating, and a roller coaster. The park declined following World War I and finally closed in 1937.

**COUNTRY CLUB.** Another sort of entertainment could be found in Kalamazoo's growing list of golf courses. The Kalamazoo Country Club, seen here under construction around the time of World War I, is located off of Oakland Drive. Another course, Acadia Brook, occupied the site of Western Michigan University. (Western Michigan University Archives and Regional History Collections.)

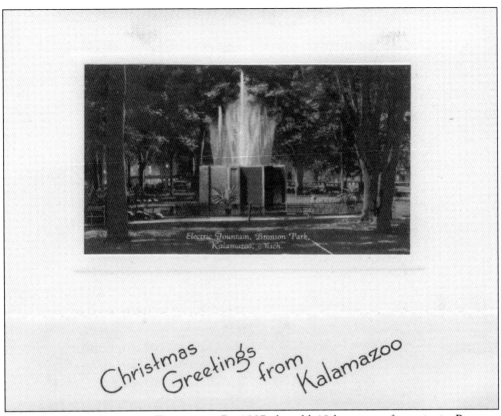

Christmas Greetings from Kalamazoo

**BRONSON PARK ELECTRIC FOUNTAIN.** By 1927 the old 19th-century fountain in Bronson Park was replaced by this electric fountain. This central landmark made an ideal subject for a Christmas card. However, within 12 years it would be replaced. (Western Michigan University Archives and Regional History Collections.)

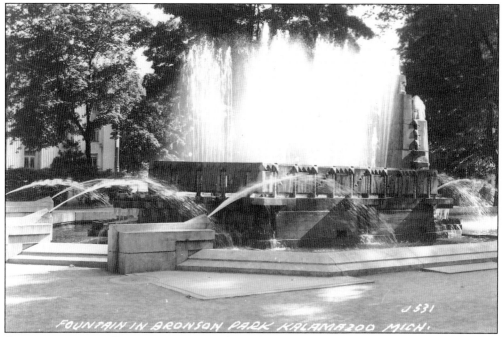

**FOUNTAIN OF THE PIONEERS.** In 1936 the Kalamazoo Business and Professional Women's Club sponsored a national contest for a replacement of the old electric fountain that graced Bronson Park. They awarded the contract to Chicago designer Alfonso Iannelli, who created a Prairie-style fountain commemorating the expulsion of the Natives from the area. Much of the project's funding came courtesy the New Deal's W.P.A.

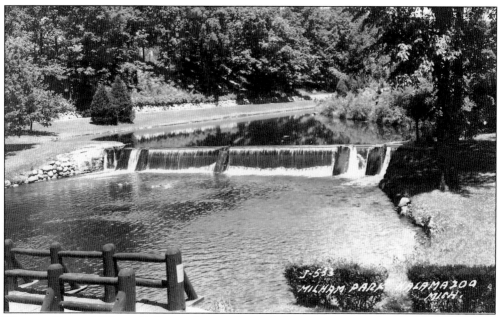

**MILHAM PARK.** Milham Park, on the outskirts of the city, was another New Deal-funded project. These upgrades included a golf course, one of the best in the area, and new landscaping that can still be enjoyed today. No longer on the outskirts, Milham remains a popular park.

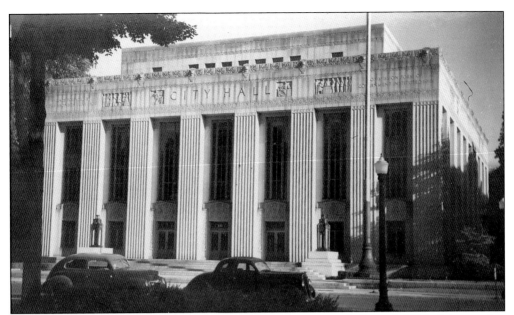

**CITY HALL.** Oddly, Kalamazoo would not have a proper city hall until 1931. Prior to that time, the government had occupied old Corporation Hall on South Burdick Street. Even with the Great Depression, the city was able to complete the new facility on Bronson Park without raising taxes or going into debt. A triumph of the Art Deco style, the building features decorative panels depicting the city's history. (Western Michigan University Archives and Regional History Collections.)

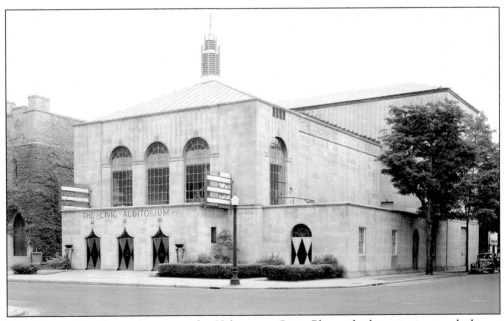

**THE CIVIC.** Just down the street, the Kalamazoo Civic Players built an intimate playhouse for their productions. Completed for the 1932 season, the building by Aymar Embury III and the Players have provided Kalamazoo with countless performances over the years. (Western Michigan University Archives and Regional History Collections.)

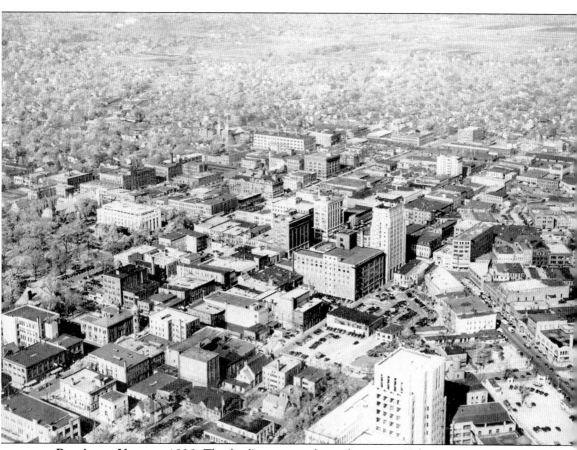

**BIRD'S-EYE VIEW, C. 1939.** This bird's-eye view shows downtown Kalamazoo around 1939. By this time the city's core had expanded to the boundaries familiar today. However, the suburban sprawl of the post-World War II era had yet to occur. Bronson Park and the new courthouse are visible on the left. The tall building on the bottom is the new Upjohn Company headquarter. (Western Michigan University Archives and Regional History Collections.)

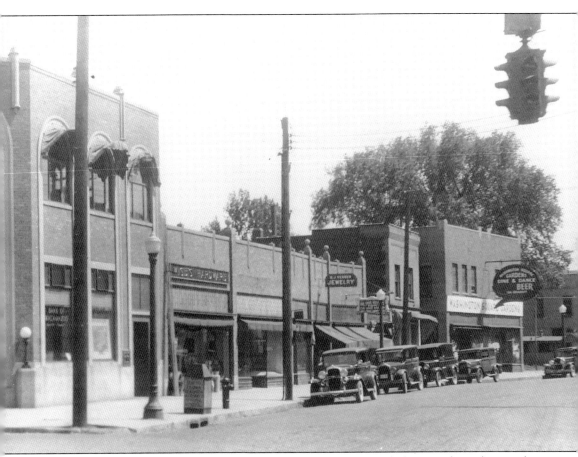

**WASHINGTON SQUARE.** One of the first "suburban" commercial districts formed around Washington Square in the Edison Neighborhood. Forming a "mini-downtown" were several businesses such as department, dime, and grocery stores. This photo is from the 1930s. (Western Michigan University Archives and Regional History Collections.)

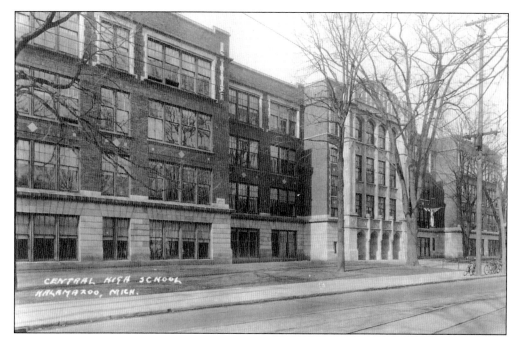

**CENTRAL HIGH.** Kalamazoo's former Central High on Westinage Avenue dates back to 1913. Built in the popular Gothic Revival style, it offered large windows for sunny classrooms. An auditorium addition seen below has provided Kalamazoo with another location to enjoy the arts. No longer a high school, the building continues as the Math and Science Center. (Western Michigan University Archives and Regional History Collections.)

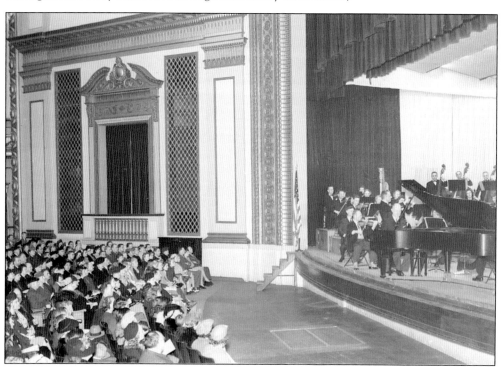

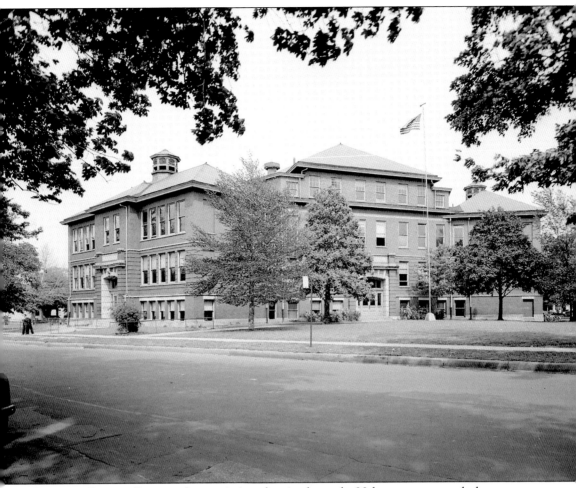

**PORTAGE STREET SCHOOL.** Just as it is today, in the early 20th century several elementary schools served Kalamazoo's children, whether they liked it or not. This building on Portage Street served the southeast side until the 1940s. (Western Michigan University Archives and Regional History Collections.)

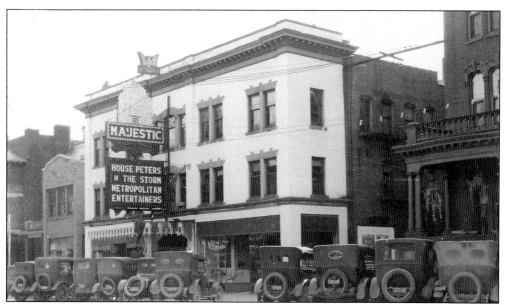

THE MAJESTIC THEATER. An elaborate electric sign marks the entrance to the Majestic Theater on South Street. First opened in 1907, the Majestic was one of Kalamazoo's first theaters to show movies and remained a premier theater for much of its life. In 1924 it was renamed the Capitol. The screen finally went silent in 1976, when the old building was removed for a parking deck.

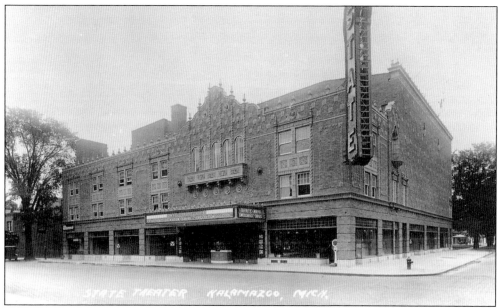

A SPANISH COURTYARD IN SOUTHWEST MICHIGAN. The State Theater, seen here in an early photo postcard, was Kalamazoo's most lavish movie palace when it opened in 1927. An example of architect John Eberson's atmospheric style, the auditorium was designed to resemble a Spanish courtyard complete with false facades, twinkling stars, and moving clouds. The last of the downtown theaters, the State currently hosts rock concerts. (Western Michigan University Archives and Regional History Collections.)

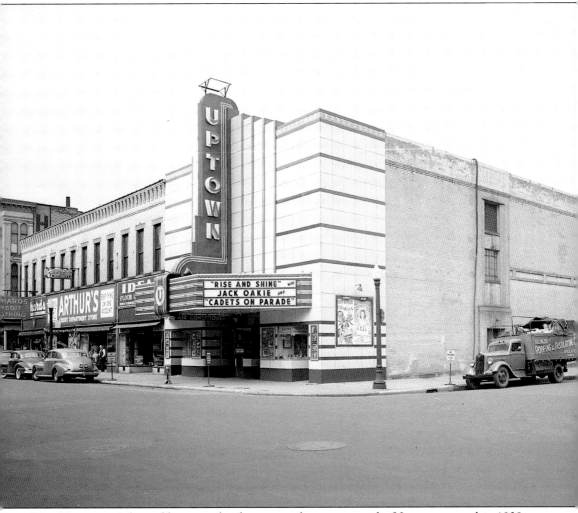

**THE UPTOWN.** A late addition to the downtown theater scene, the Uptown opened in 1938. Architecturally, the building was a dramatic departure from the earlier Majestic and State. The building's classic Art Deco style, which was installed over the old Maccabee Temple, made it a distinctive addition to the North Burdick commercial district. (Western Michigan University Archives and Regional History Collections.)

**END OF AN ERA.** This 1977 photo of the former Uptown symbolizes the demise of the downtown movie theaters. Declining patronage in the 1950s, 1960s, and 1970s brought about the closure of the Fuller, Michigan, Uptown, and Capitol. In this view, there is little that is recognizable of the former Uptown, closed for 19 years. The building would last until 1991 when, like most of its competitors, it was razed. The Kalamazoo Valley Museum occupies the site today. (Western Michigan University Archives and Regional History Collections.)

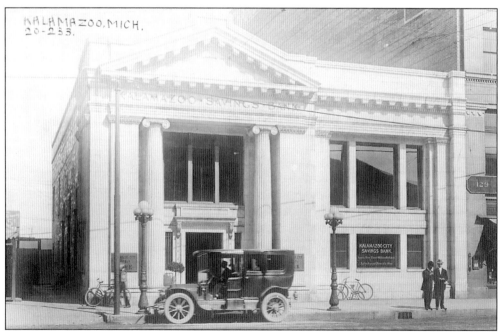

**OLD MEETS NEW.** This photograph dates from around 1910 and shows the most modern of devices, the automobile, and the old classical taste prevalent in architecture. This Greek façade served the Kalamazoo Savings Bank in 1909. It is the city's finest example of commercial Greek architecture.

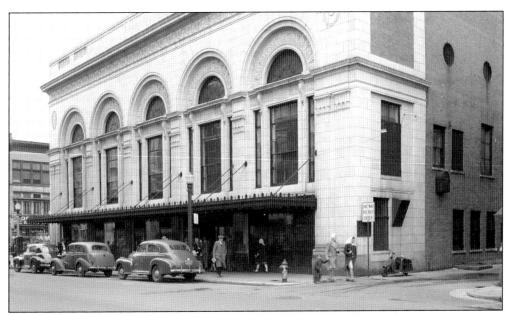

**First National Bank.** The First National Bank on Burdick and Main Streets was a Kalamazoo institution for over a century. Originally organized in 1856, First National has done business at this location since the 1860s. The building shown here was built in 1917 with a façade of elaborate terra cotta. In 1997, First of America, as First National was then known, was bought out by National City Bank, which continues to do business at this location. (Western Michigan University Archives and Regional History Collections.)

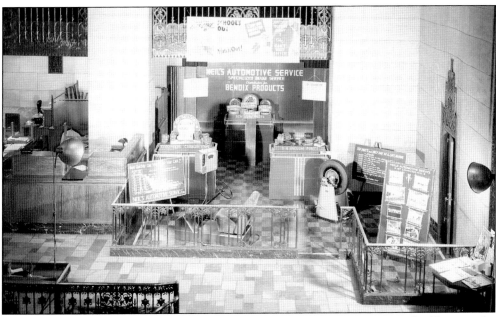

**American National Bank Lobby.** One of Kalamazoo's more impressive buildings is the American National Bank. Built for the Bank of Kalamazoo in 1929, the building survived the Depression but the bank itself did not. This photograph shows a display set up in the building's mammoth lobby. (Western Michigan University Archives and Regional History Collections.)

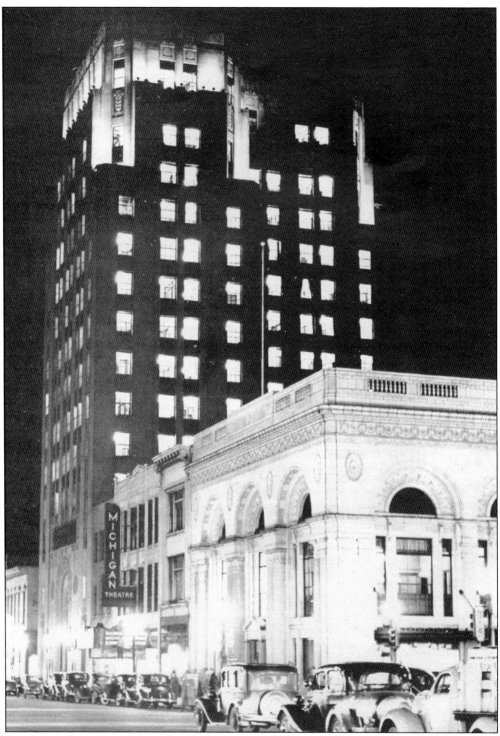

**A GLOWING TOWER.** The American National Bank Building and the First National Bank Building are aglow with light in this 1939 view. (Western Michigan University Archives and Regional History Collections.)

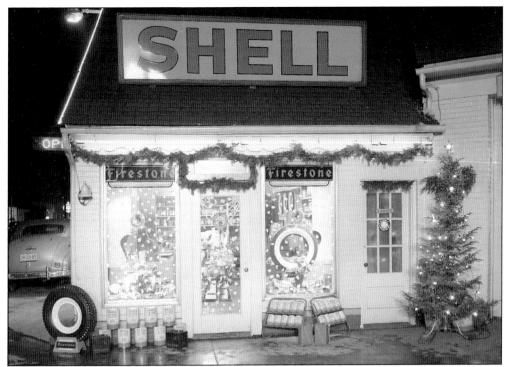

ALL SET FOR CHRISTMAS. The increasing presence of automobiles created a need for service stations. Stations such as this one promptly popped up all over town in the 1920s. This station, seen in the mid-1940s, is decorated for the holidays. (Western Michigan University Archives and Regional History Collections.)

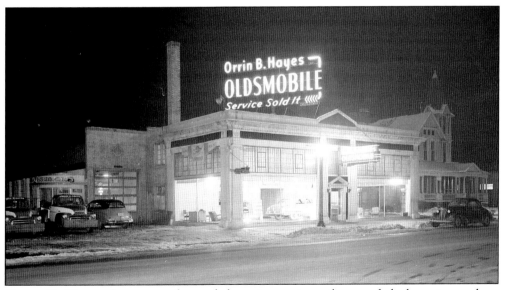

ORRIN B. HAYES. Just as people needed service stations, they needed places to purchase automobiles. Businesses such as Orrin B. Hayes' appeared on the scene. Built around 1920, this dealership is a unique blend of a classical design and a service and display facility. (Western Michigan University Archives and Regional History Collections.)

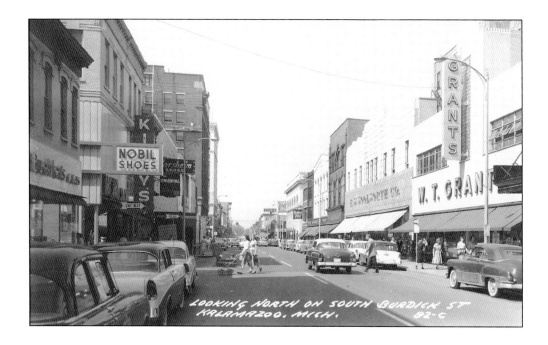

LOOKING NORTH ON SOUTH BURDICK ST
KALAMAZOO, MICH.
82-C

**SOUTH BURDICK.** South Burdick Street was a busy place in the 1950s. Several department stores like Gilmore's, Kresge's, J.C. Penney, and Grant's vied for business. Suburban malls had yet to gain the upper hand. However, within a few years, the vehicular traffic would be removed as city leaders sought ways to compete with new suburban shopping districts.

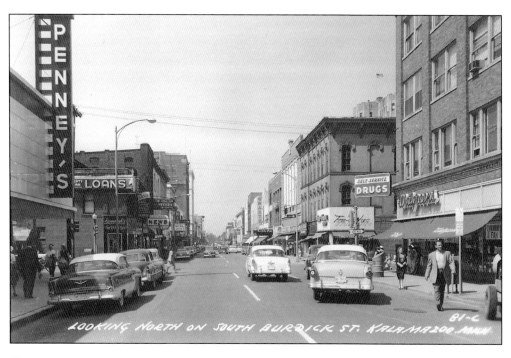

LOOKING NORTH ON SOUTH BURDICK ST. KALAMAZOO, MICH.
81-C

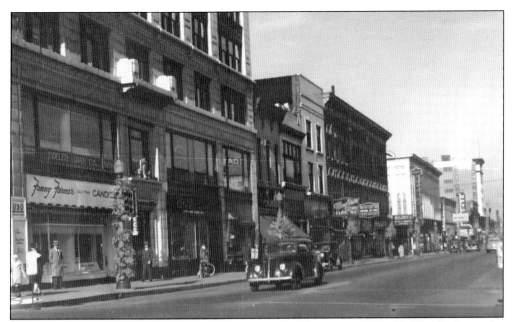

**NORTH BURDICK.** This view of North Burdick from the time of World War II shows the storefronts that would be removed in early 1970s for the Kalamazoo Center. A sign on the Hanselman Building directs people 3 blocks north to the U.S.O. office. (Western Michigan University Archives and Regional History Collections.)

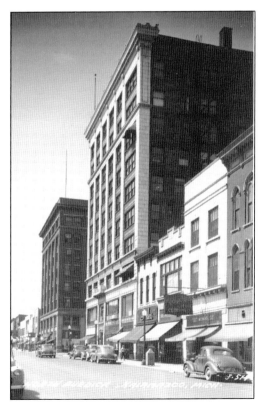

**NORTH BURDICK.** This is a shot of the same group of buildings, but looks south. We are shown a detailed view of the Hanselman Building's less glamorous side.

THE KALAMAZOO MALL. In 1959 downtown Kalamazoo undertook a bold experiment in an effort to compete with suburban malls. The nation's first pedestrian mall opened along North and South Burdick Street. In place of cars, trees, fountains, and grass created a park-like setting. Ironically, traffic was reintroduced 40 years later for the same reasons the mall was built.

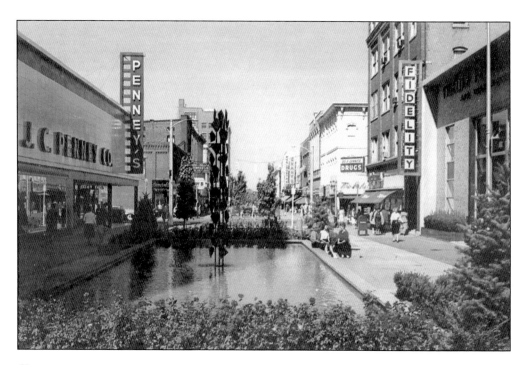

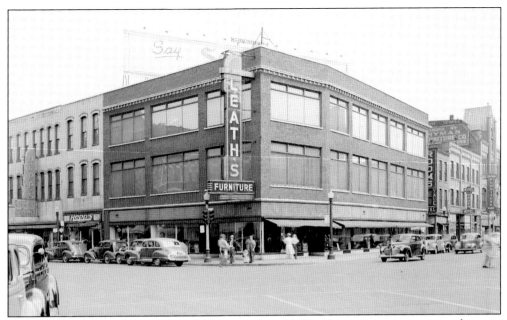

CORNER OF PORTAGE AND EAST MICHIGAN. Leath's Furniture store operates in what was once known as Folz's Corner. This view down Portage was taken in the mid-1940s. Parts of this end of downtown had already developed a run-down look that was not shed until the 1980s. (Western Michigan University Archives and Regional History Collections.)

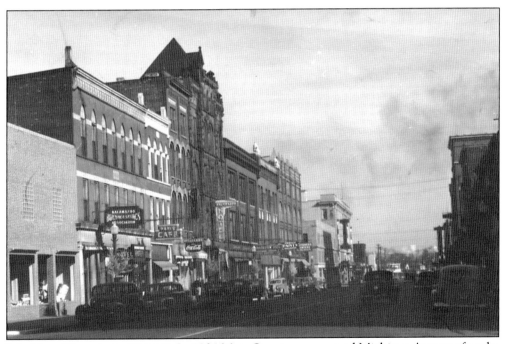

IT'S NOW MICHIGAN AVENUE. In 1934 Main Street was renamed Michigan Avenue after the completion of a repaving project. This view is down East Michigan from Portage Street. The view remains much the same today. (Western Michigan University Archives and Regional History Collections.)

EASTERN GATEWAY. Kalamazoo's eastern gateway, the intersection of Kalamazoo and East Michigan Avenues, has always had an industrial look to it. These 1940s photographs, one eastbound, the other west, were taken for insurance purposes after an automobile accident. (Western Michigan University Archives and Regional History Collections.)

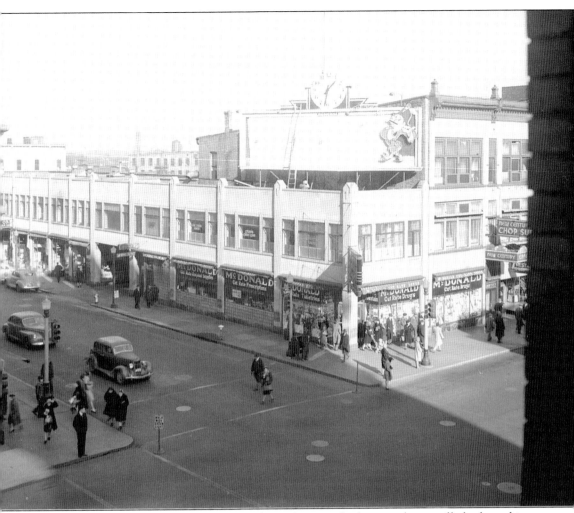

**CORNER OF BURDICK AND MICHIGAN.** The Kalamazoo had yet to be installed when this 1950 photograph of the Michigan-Burdick corner was snapped from a second floor window. McDonald Drugs occupies a significant portion of the Dewing Building. (Western Michigan University Archives and Regional History Collections.)

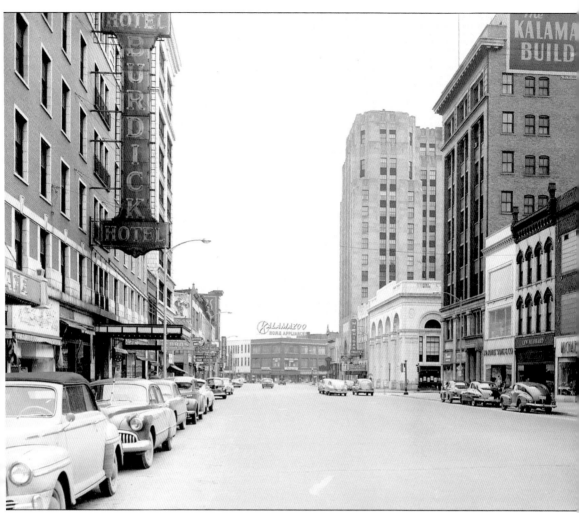

**WEST MICHIGAN AVENUE.** The massive vertical sign of the Burdick Hotel was a commanding presence on Michigan Avenue in 1950. By 1973 the Burdick Hotel and every other building on the block would be gone. The Kalamazoo Center, today's Radisson Plaza Hotel, opened on the site in 1975, drastically altering the cityscape. (Western Michigan University Archives and Regional History Collections.)

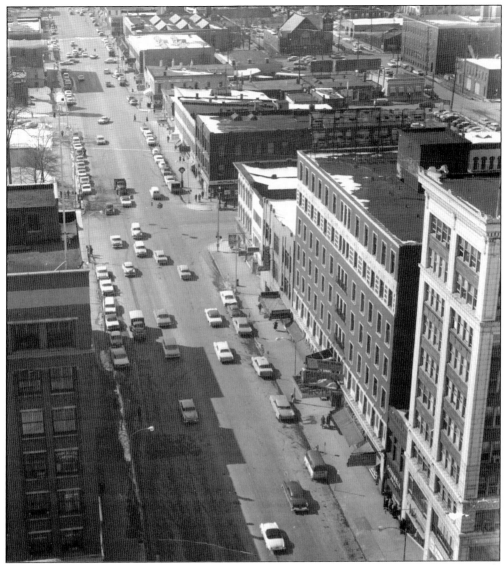

**WEST MICHIGAN FROM THE AIR.** The Kalamazoo National Bank makes an interesting perch from which to view West Michigan Avenue in the late 1940s. The full block frontage of the Burdick block is visible. The cold winter weather appears to have kept most pedestrians indoors. (Western Michigan University Archives and Regional History Collections.)

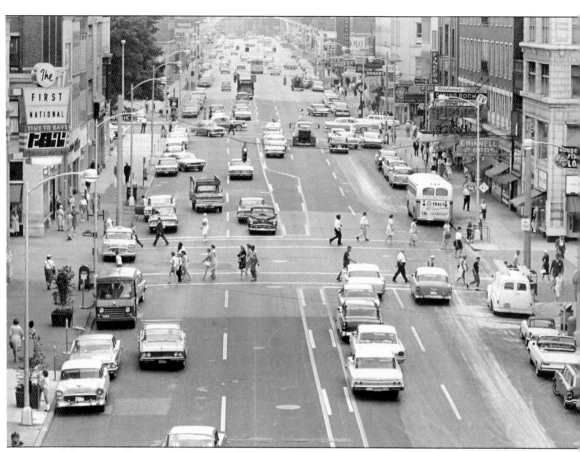

**MICHIGAN AVENUE.** Downtown businesses still appear to enjoy a great deal of foot traffic in this 1963 view of Michigan Avenue. The most notable features of this photograph are the many signs that dominate the facades. The names of several Kalamazoo institutions are visible. They include the First National Bank, the Burdick Hotel, and Finger's Furs. The Michigan News Agency is visible next to the Greyhound Terminal. Ten years later, the Burdick Hotel and Finger's Furs would give way to the Kalamazoo Center. The First National name is now a memory. Only the Michigan News Agency remains today, remarkably with the same sign. (Western Michigan University Archives and Regional History Collections.)

# *Three*

# A City of Industries

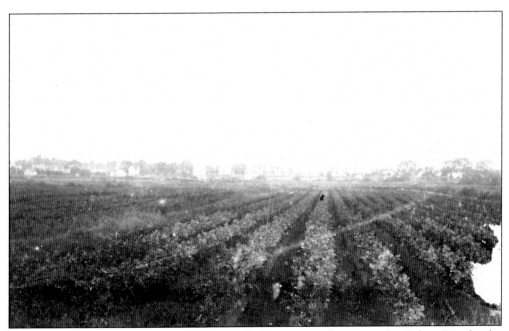

**THE CELERY CITY.** In the late 19th century, Kalamazoo was known as the Celery City for the area's large celery industry. This picture shows a celery field on South Burdick Street. However, as the new century dawned and factory jobs became more plentiful, the celery industry gradually disappeared. (Western Michigan University Archives and Regional History Collections.)

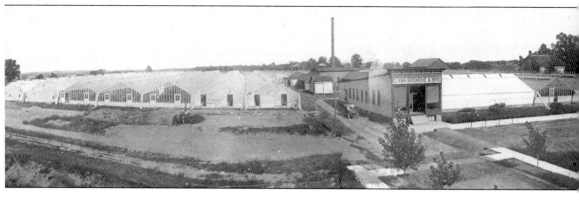

GREENHOUSES. With the demise of celery in the early 20th century, many celery farmers converted their operations to greenhouses for bedded plants. As a result, Kalamazoo developed a bedded plant industry that remains strong today. The G. Van Bochove & Bro. Greenhouses on Portage Street, formerly celery shippers, were an early such supplier.

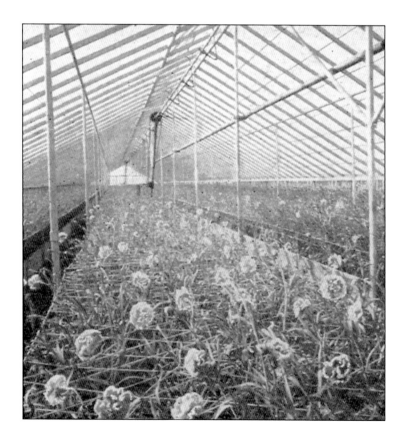

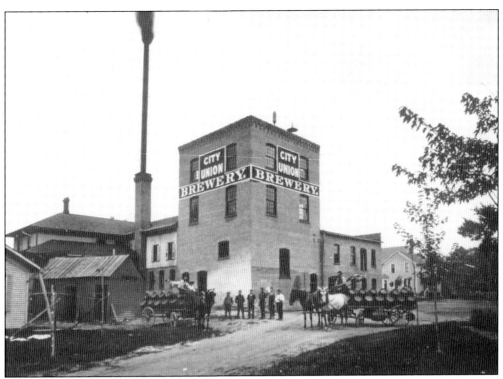

**THE BREW FROM KALAMAZOO.** Prior to going dry in 1915, Kalamazoo had an operating brewery known as the City Union Brewery. No longer able to produce "The Brew from Kalamazoo" the company went out of business in 1915. Kalamazoo Creamery moved in shortly thereafter. The building on Portage Street still stands and is seen here before and after an expansion gave it a castle-like appearance.

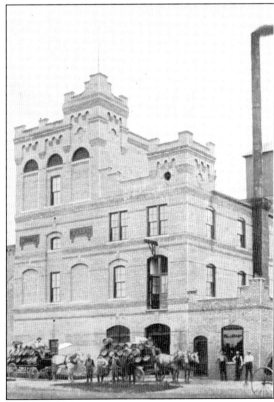

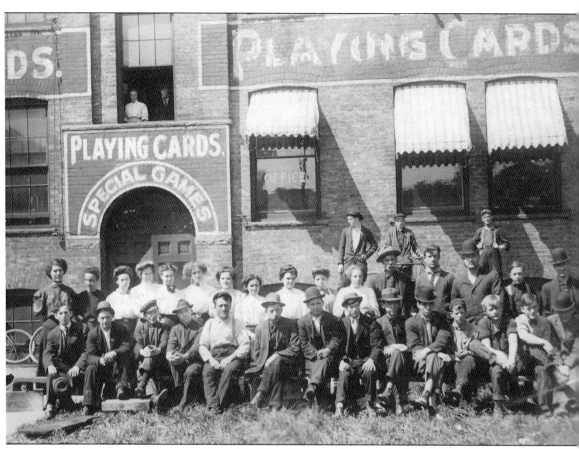

**THE AMERICAN PLAYING CARD CO.** The American Playing Card Company is an example of a national corporation that had established a presence in Kalamazoo. One hundred forty-five local employees produced a daily output of 18,000 decks of cards. This early 1900s photograph shows a small group of these employees outside of the factory. (Western Michigan University Archives and Regional History Collections.)

**UPJOHN.** One of Kalamazoo's most important companies started when William E. Upjohn developed the "friable pill" in 1885. By the 1950s, the company had grown into one of the nation's top pharmaceutical companies with a labor force of over 5,700. Merged with Pharmacia in 1995, the former Upjohn Company is currently part of Pfizer. The above photo shows the first Upjohn factory, southeast of downtown. The below photo shows the massive Headquarters built in 1935. (Western Michigan University Archives and Regional History Collections.)

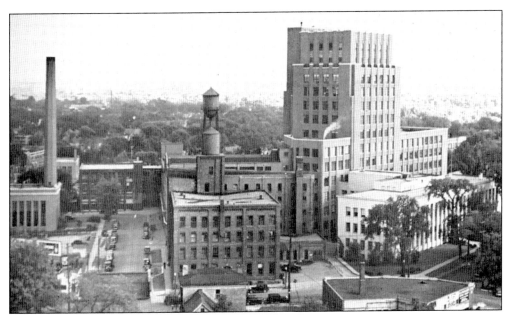

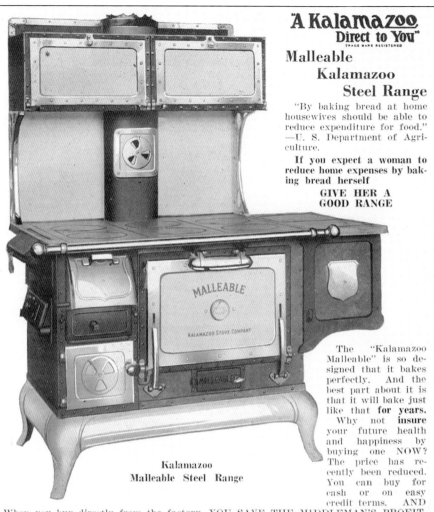

THE KALAMAZOO STOVE COMPANY. With the catchy slogan "A Kalamazoo Direct to You," the Kalamazoo Stove Company did booming business during the early decades of the century. The stoves themselves were of high quality, but the slogan probably did just as much to sell them than any feature of their construction. Western Michigan University Archives and Regional History Collections.)

CHECKER CAB. Long a recognizable feature of the streets of major cities, the Checker Cab Corporation established Kalamazoo as a center for automobile production. Although the company no longer produces cabs, the name Checker remains synonymous with taxis.

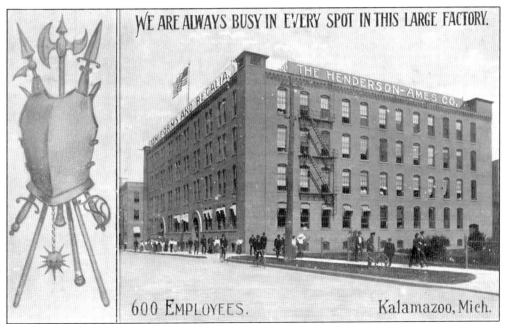

HENDERSON-AMES. This large factory on North Park Street produced uniforms, regalia, and other such supplies for military and civic organizations. Over 600 people were employed here from 1901 until 1933, when the company merged and shut down local operations.

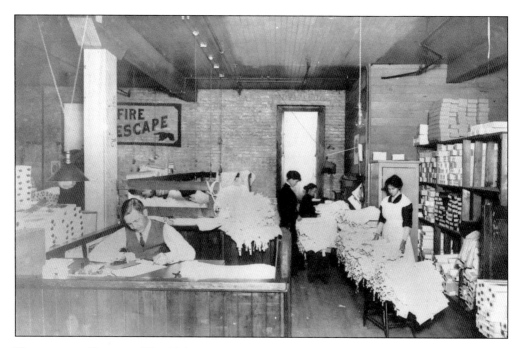

**KALAMAZOO CORSETS.** The Kalamazoo Corset Company, formerly the Featherbone Corset Company, did a thriving business prior to the 1920s. With over 800 employees, the company could produce 1.5 million corsets a year. However, after World War I these tight undergarments went out of style and the company entered a slow decline. The above photo shows a typical interior scene. Below we see the company's baseball team. (Western Michigan University Archives and Regional History Collections.)

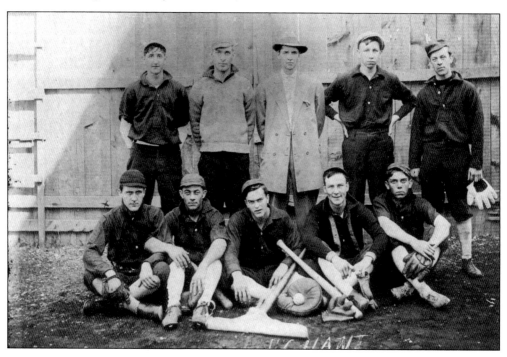

**THE PAPER CITY.** Kalamazoo's greatest industry in the 20th century was paper production. By the 1930s, more paper was produced in Kalamazoo than anywhere else in the world. The city's first mill was the Kalamazoo Paper Company, organized in 1866 by Benjamin F. Lyon. Lyon brought in Samuel Gibson, an experienced mill operator from Massachusetts. Gibson, seen here, would play a key role in establishing the paper industry in the Kalamazoo region. Not only would he make the Kalamazoo Paper Company a success, but he would help create a pool of men that would go on to establish several other mills in the area. (Western Michigan University Archives and Regional History Collections.)

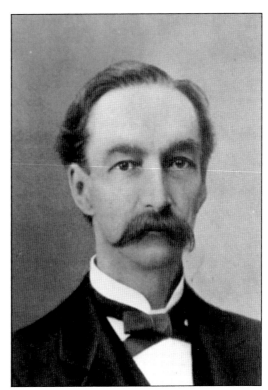

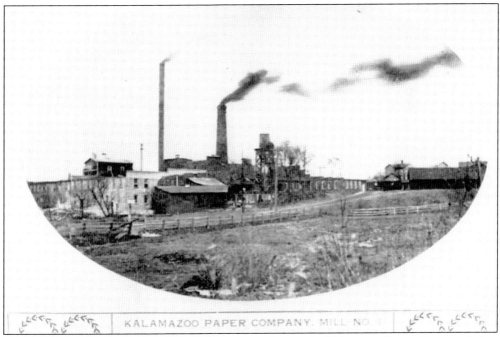

KALAMAZOO PAPER COMPANY. MILL NO

**THE KALAMAZOO PAPER COMPANY.** This picture depicts the Kalamazoo Paper Company's first mill. From this modest facility, a powerful company and industry would be born. This mill burned in 1871. Under the direction of Gibson, a new mill of fireproof construction quickly replaced it. (Western Michigan University Archives and Regional History Collections.)

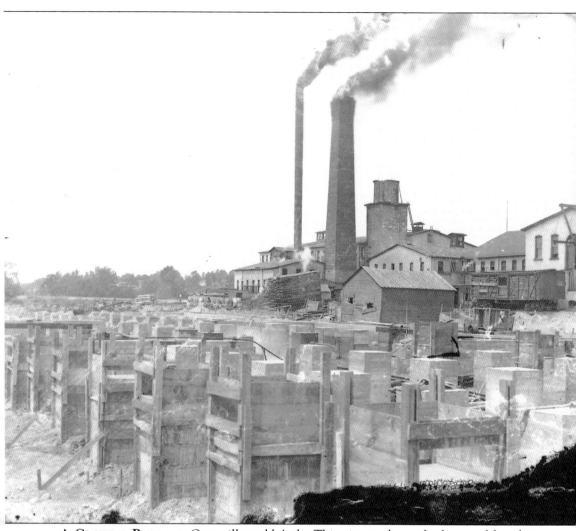

**A GROWING BUSINESS.** One mill wouldn't do. This picture shows the laying of foundations for additional mills at the Kalamazoo Paper Company site. Between the years 1900 and 1917, a new mill opened annually in the Kalamazoo valley. (Western Michigan University Archives and Regional History Collections.)

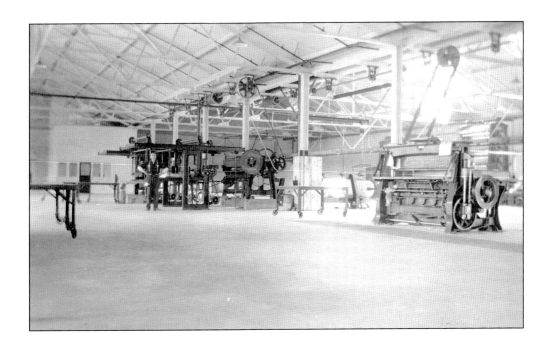

INTERIOR VIEWS. These early photographs show the interior conditions and machinery of the Kalamazoo Paper Company. Paper mills were generally well-lit and well-ventilated buildings constructed of fireproof materials. (Western Michigan University Archives and Regional History Collections.)

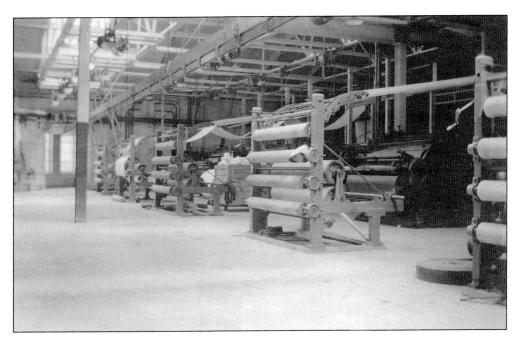

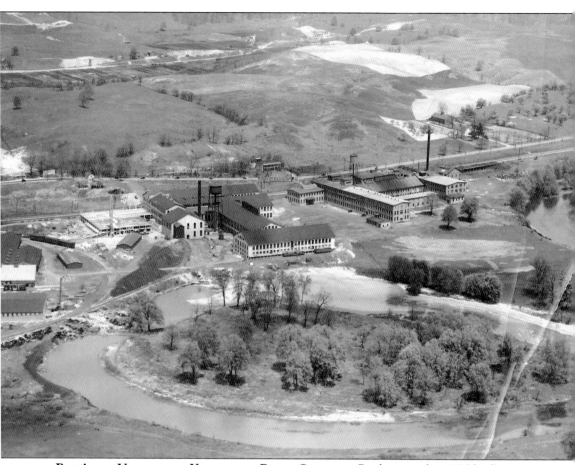

**BIRD'S-EYE VIEW OF THE KALAMAZOO PAPER COMPANY.** By the time this 1925 bird's-eye view was taken, the Kalamazoo Paper Company's complex had grown to include several mills. By the company's peak, the complex seen here would nearly double in size. As this picture illustrates, all paper mills were built near rivers or streams as paper production required large amounts of flowing water. (Western Michigan University Archives and Regional History Collections.)

**MOURNING A NATIONAL TRAGEDY.** When President McKinley was assassinated at the 1900 Buffalo World's Fair, the Kalamazoo Paper Company employees assembled this memorial to their fallen leader. (Western Michigan University Archives and Regional History Collections.)

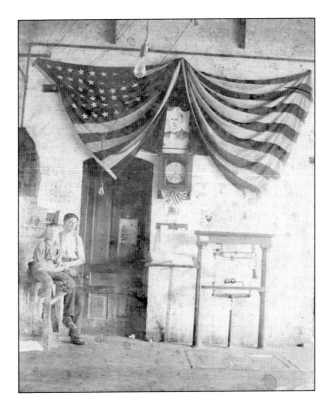

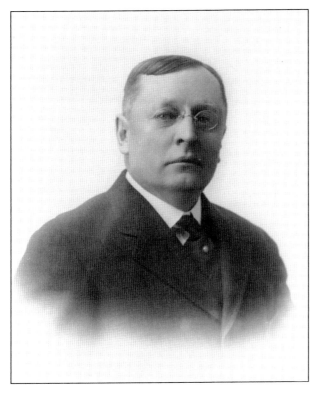

**BARDEEN.** The Kalamazoo Paper Company would become the trunk from which a family tree of local paper mills sprang forth. This occurred when former Kalamazoo Paper Company executives set out on their own. George E. Bardeen, Samuel Gibson's secretary, was one such individual. He founded the Bardeen Paper Company in Otesgo in 1887. (Western Michigan University Archives and Regional History Collections.)

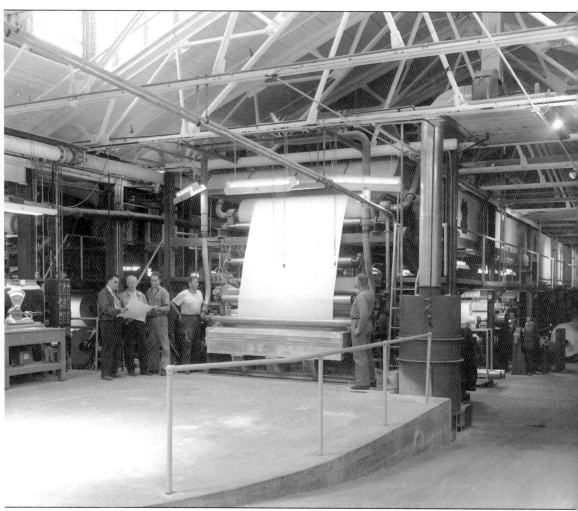

PRODUCTION IN 1956. By 1956 the general processes of papermaking at the Kalamazoo Paper Company had changed little from the previous interior views. However, the equipment shown here is more modern and efficient. (Western Michigan University Archives and Regional History Collections.)

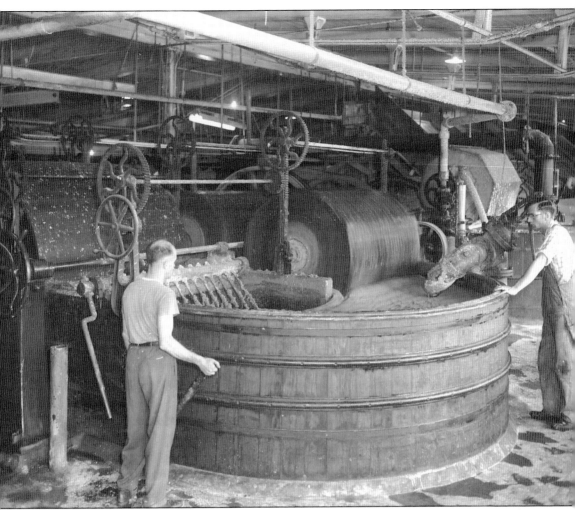

**PRODUCTION IN 1956.** Paper materials came from a variety of materials such as bark, wood, and rags. In order to produce the pulp from which paper can actually be made, these materials must be beat and broken down. Massive machines like these accomplished the task. (Western Michigan University Archives and Regional History Collections.)

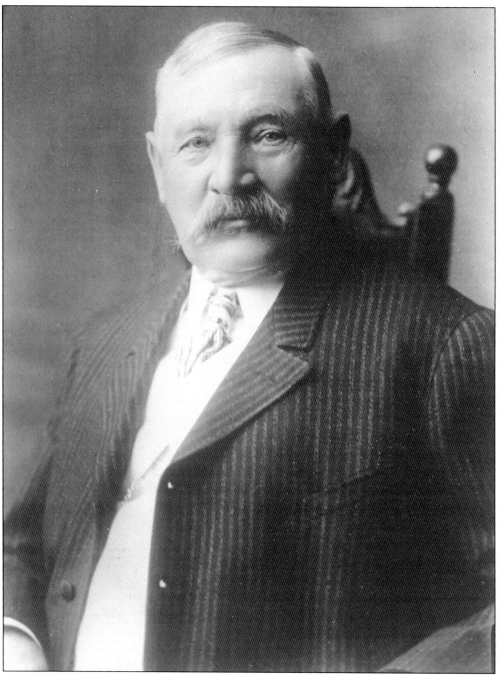

**NOAH BRYANT.** In 1896 another Kalamazoo Paper Company executive, Noah Bryant, would strike out on his own. Bryant, along with Frank Milham, established the Bryant Paper Company on Alcott Street. Specializing in book grade paper, the mill experienced rapid success. (Western Michigan University Archives and Regional History Collections.)

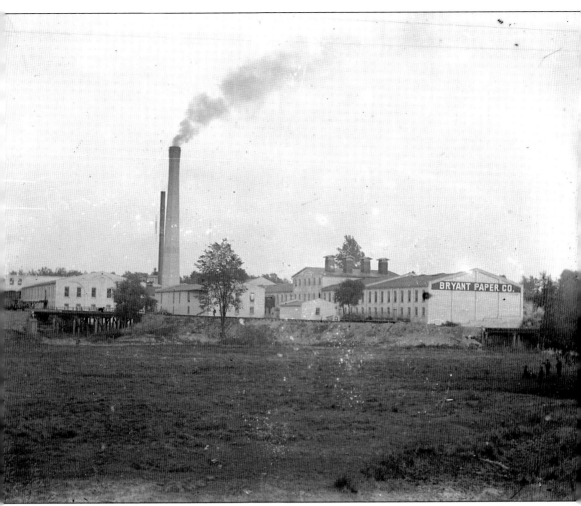

**THE BRYANT PAPER COMPANY.** This photograph shows the Bryant Paper Company shortly after its founding. It doubled its size in 1902 and expanded further in 1908. By the 1930s, it would encompass a sprawling site and produce more book grade paper than any other mill in the world. (Western Michigan University Archives and Regional History Collections.)

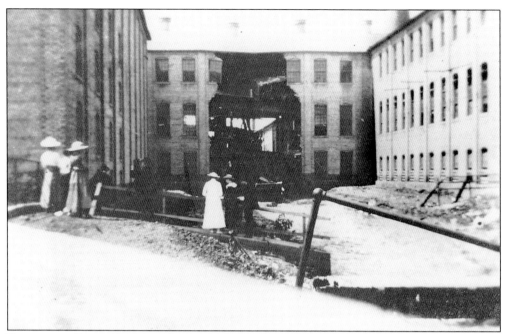

**PAYING THE PRICE.** Occasionally, paper companies paid the price for their water consumption. In this 1916 incident, a flood tore through a mill at the Bryant Paper Company and resulted in extensive damage. Today, much of the Kalamazoo River's pollution can be traced back to paper production. (Western Michigan University Archives and Regional History Collections.)

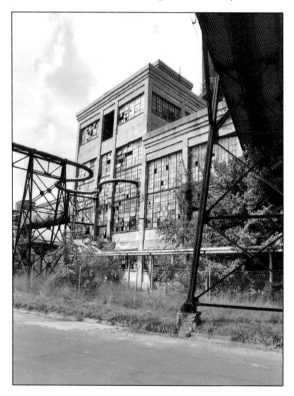

**THE END OF AN INDUSTRY.** There is no mistake that in the last few years Kalamazoo's paper industry has come close to its demise. Mergers and a changing industry have shuttered many of the mills. Nothing symbolizes this more than the abandoned Bryant Paper Mill complex. Closed since the early 1990s, the site, which played such an important role in Kalamazoo's 20th century identity, will soon vanish. Likewise, the factories of the former Kalamazoo Paper Company and Kalamazoo Vegetable Parchment Company are dormant.

# *Four*

# THE KALAMAZOO
# STATE HOSPITAL

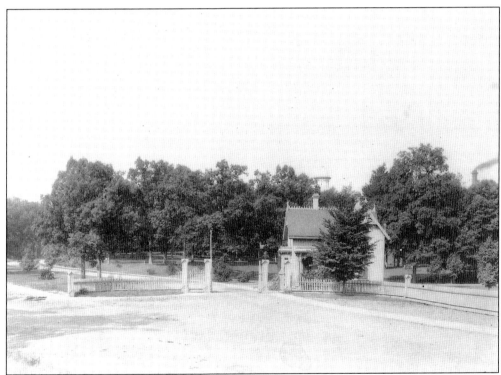

ENTRANCE TO THE STATE HOSPITAL. Admitting its first patient in 1859, the Kalamazoo State Hospital has played a long and important role in the history of Kalamazoo. Its presence and physical structure have been illustrative of both philosophy and medical practices of the "insane." This c. 1900 photograph shows the entrance of the hospital from today's Oakland Drive. On the right, the Gothic-style gatehouse can be seen; to this day it is a local landmark. (Western Michigan University Archives and Regional History Collections.)

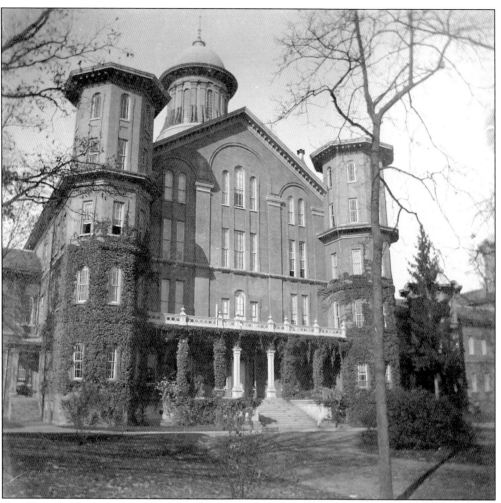

**THE FEMALE DEPARTMENT.** By the mid-19th century, many people, including Kalamazooan and then-Governor Epahroditus Ransom, felt the need to establish an alternative to incarceration of the insane. Thus, in 1848, the State Legislature established the first state hospital in Kalamazoo. However, it would not be until 1853 that architect Samuel Sloan received the commission, and not until 1859 that the first building, seen here, was finished.

Under the advice of the progressive consultant Dr. Thomas Kirkbride, the building was constructed in adherence to the "Linear Plan," which dictated everything from building placement, materials, landscaping. Consisting of a central building with multiple wings, this layout allowed for the isolation and treatment of patients by disorder. The "Linear Plan" became the standard asylum design for many years. (Western Michigan University Archives and Regional History Collections.)

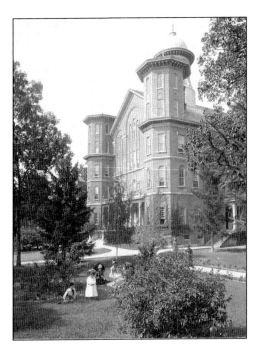

THE FEMALE DEPARTMENT. These two c. 1870s photographs show the central portion of the Female Department in a pleasant park-like setting. Groups of visitors have been posed strolling along the pathways and enjoying the shade. The building's prominent architectural features were its central cupola and side towers. These disappeared when the roof was raised around 1910. The building was completely demolished in 1966, the victim of improved treatments and medications. (Western Michigan University Archives and Regional History Collections.)

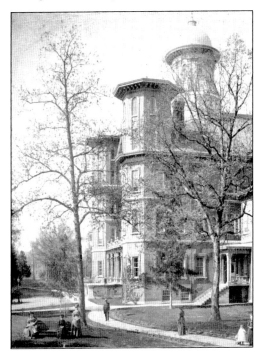

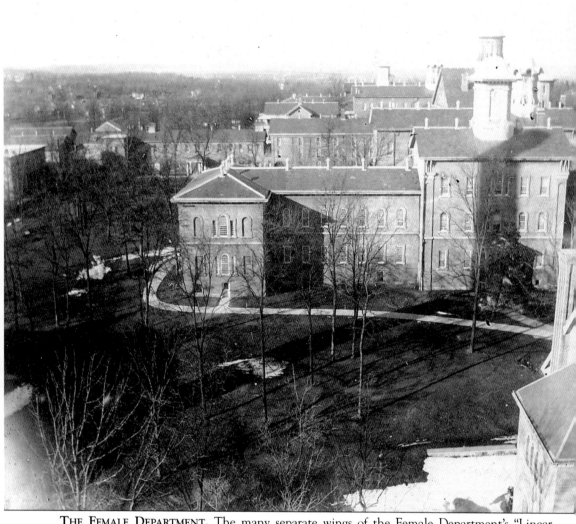

**THE FEMALE DEPARTMENT.** The many separate wings of the Female Department's "Linear Plan" design are evident in this northward view from the roof of another hospital building. (Western Michigan University Archives and Regional History Collections.)

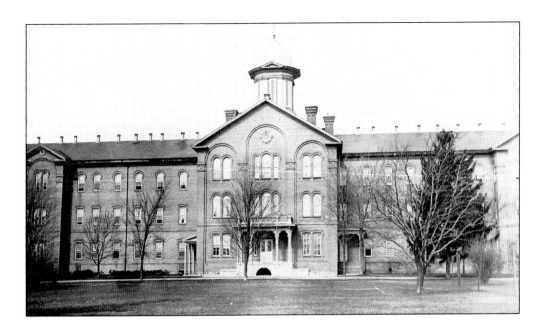

THE MALE DEPARTMENT. By 1874 the patient population of the state hospital had grown enough to warrant the construction of a second large "Linear Plan" building just to the south of the original. This long brick structure with its cupolas and Italianate features was similar to its predecessor. As with the Female Department, it eventually outlived its utility and was razed in 1975. (Western Michigan University Archives and Regional History Collections.)

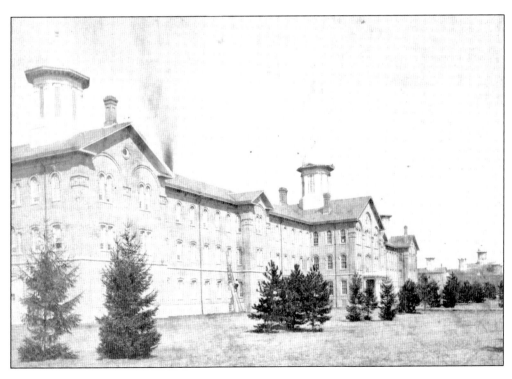

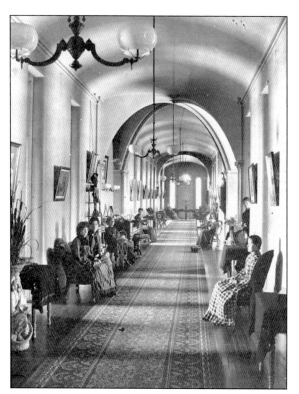

INTERIOR OF THE FEMALE DEPARTMENT. Victorian furnishings attempt to give this corridor of the Female Department a more comfortable, less institutionalized look. (Western Michigan University Archives and Regional History Collections.)

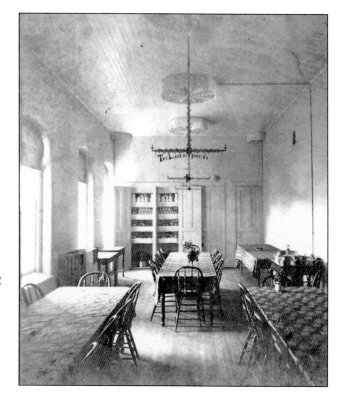

DINING ROOM. The designers were somewhat less successful in creating a home-like atmosphere with this bare-bones dining room. The writing above the cabinets says that "The Lord Will Provide," a phrase not likely to be found today in a state facility. (Western Michigan University Archives and Regional History Collections.)

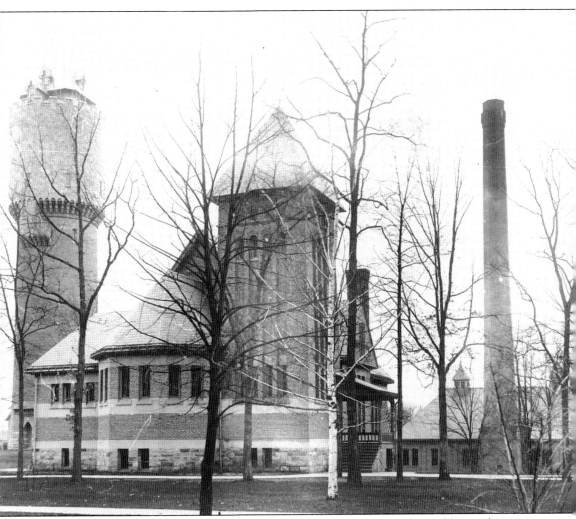

**A PLACE TO PRAY.** As the state hospital grew, new facilities beyond additional hospital space were created to service the growing needs of the institution and its patients. In this scene, two utilitarian structures, the water tower and powerhouse, flank the 1890 chapel. (Western Michigan University Archives and Regional History Collections.)

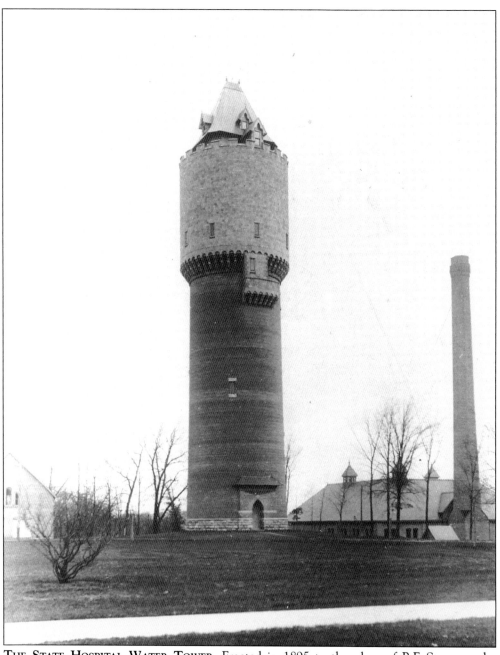

THE STATE HOSPITAL WATER TOWER. Erected in 1895 to the plans of B.F. Stratton, the tower is an excellent example of the Gothic Revival style. Due both to its central location on the hospital grounds and its 175-foot height, the tower has been the most visible symbol of the hospital and city since its completion. In this photograph, it looms over the smokestack of the powerhouse. (Western Michigan University Archives and Regional History Collections.)

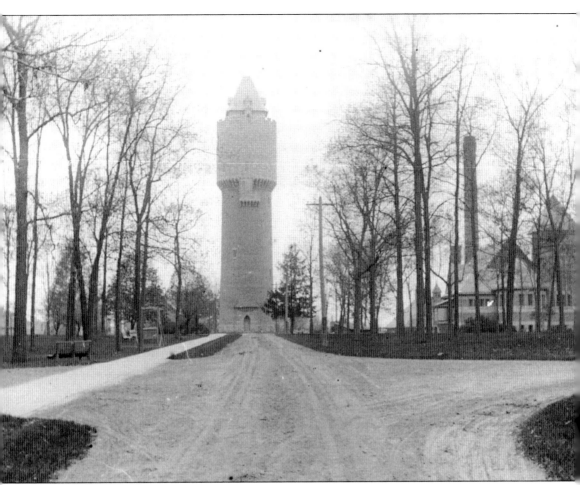

**AN UNOBTAINABLE VIEW.** This photograph provides a picturesque view of the water tower that cannot be witnessed today. The 1939 Administration Building wrapped around the tower, hiding its lower portions within the courtyard. Beyond its physical presence, the tower has played a significant role in the city's history. On the evening of December 9, 1909, it saved much of downtown from being consumed by the Burdick Hotel fire. Hoses were run downtown from the tower to help extinguish the blaze. (Western Michigan University Archives and Regional History Collections.)

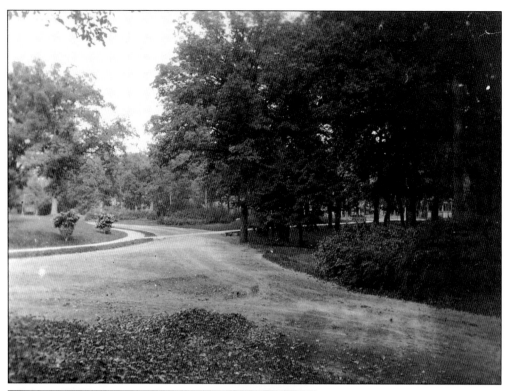

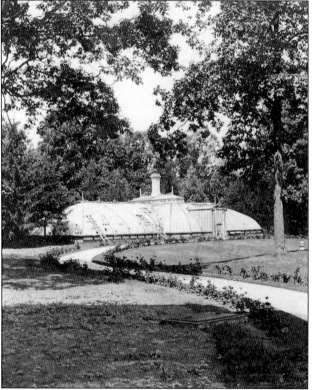

**THE GROUNDS.** The state hospital occupies a large site that was initially on the outskirts of the city. The grounds were landscaped with walkways and trees in a park-like setting. Included on the grounds was an elaborate greenhouse, seen in this 1870s stereopticon view. Typical of greenhouses of the day, it was built in the Gothic style. The greenhouse provided a distraction from the general activities of the hospital. (Western Michigan University Archives and Regional History Collections.)

**HOSPITAL VISITORS.** If it were not for the Female Department seen in the background, it would be hard to tell that this photograph of an unidentified group was taken at the state hospital. The individuals do not appear to be patients or staff, nor does this resemble a typical hospital scene. (Western Michigan University Archives and Regional History Collections.)

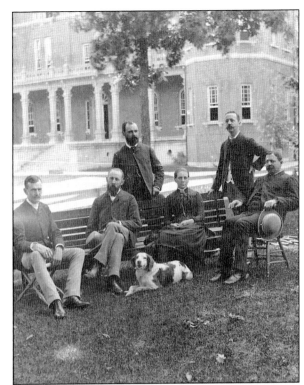

**HOSPITAL ROOM.** This view of a crowded hospital room provides a glimpse into life at the state hospital. Unlike the well-decorated hallways or landscaped grounds, this room appears bare and dismal. The only hint of color is the potted plant in the center of the room. (Western Michigan University Archives and Regional History Collections.)

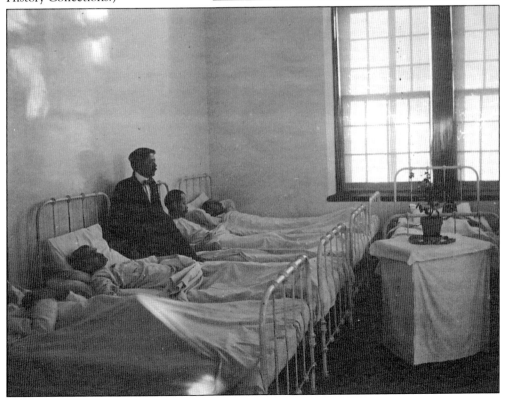

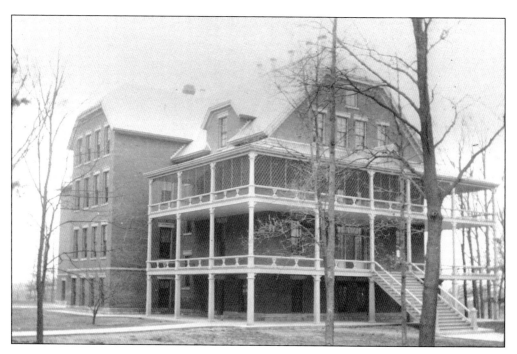

COTTAGES. Towards the end of the 19th century, the hospital administration began to look towards "cottage" buildings for expansion. The structures were intended to house the growing population of patients that did not require supervision in the wards. With their elegant rooflines and large porches, several of these facilities were built and expanded between 1897 and 1910. The above photograph shows the Burns Hospital for Men and below is the Monroe Hospital for Women. (Western Michigan University Archives and Regional History Collections.)

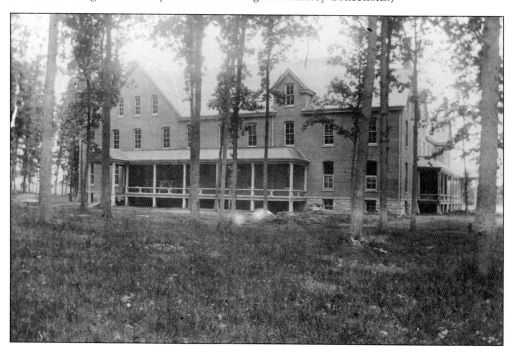

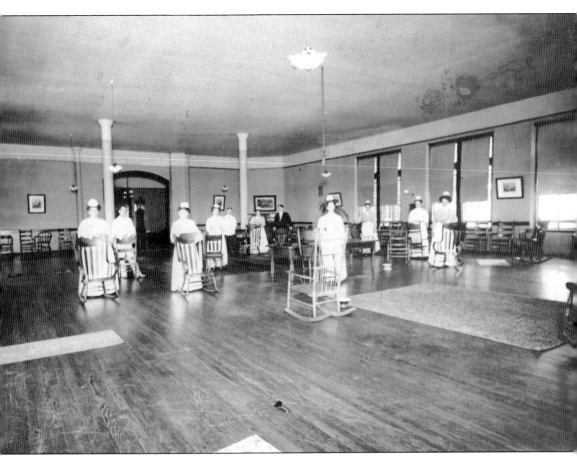

**COTTAGE INTERIOR.** Nurses and staff pose for this photograph in the lounge of an unidentified hospital cottage. The spacious and well-lit interior is a vast improvement over the gloomy hospital room seen previously. (Western Michigan University Archives and Regional History Collections.)

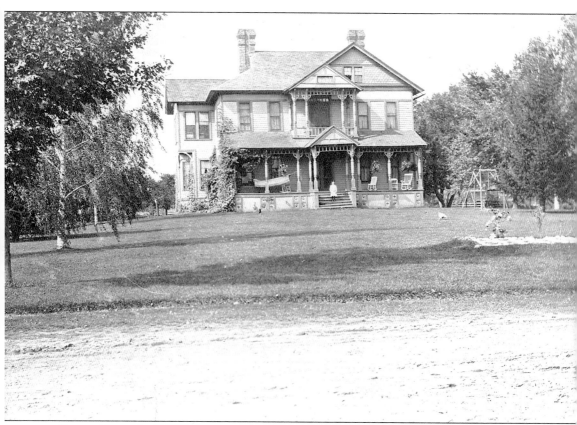

**BROOK FARM.** In 1885 Kalamazoo State Hospital would be the country's first to use "colonies." In this system, patients who did not require the traditional ward set-up would be treated in farm-like settings. The colony could provide both work for patients and food for the hospital. This photo shows the cottage of Brook Farm, a 250-acre facility on Douglas Avenue. A larger such colony, Colony Farm, would open two years later at today's Asylum Lake. (Western Michigan University Archives and Regional History Collections.)

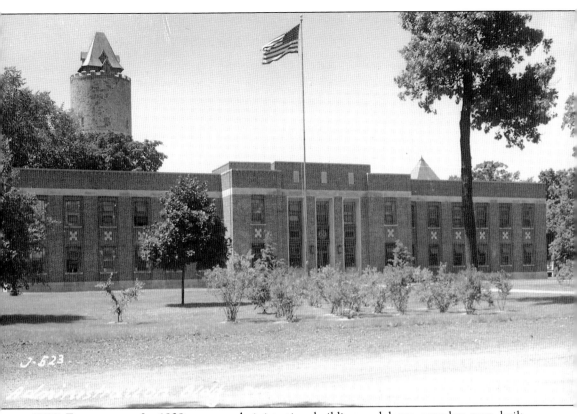

**1939 EXPANSIONS.** In 1939 a new administration building and large complex were built between the old Female and Male Departments. These buildings comprise the majority of the present-day state hospital. The facilities seen in this photograph, taken from Oakland Drive in the mid-1940s, appear virtually identical today.

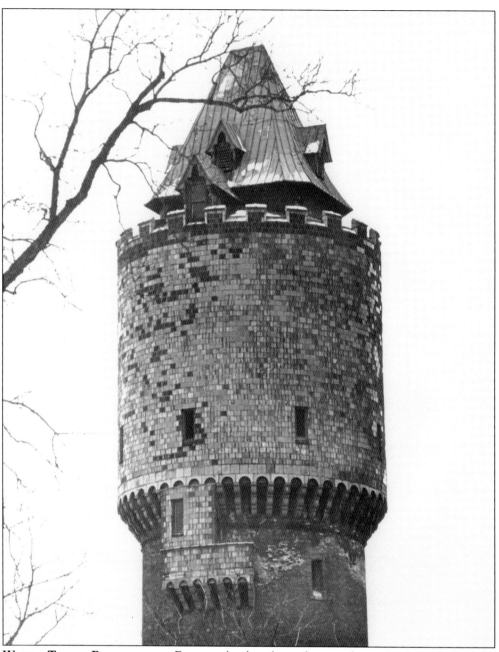

**WATER TOWER RESTORATION.** Fortunately, demolition has not been the fate of all of the hospital's historic structures. Due to the tower's unstable condition, plans to raze the tower were announced in 1974. A successful public effort raised the funds necessary for its restoration. The completely refurbished building was ready by 1976. This early 1970s photograph shows the tower prior to restoration work. (Western Michigan University Archives and Regional History Collections.)

# *Five*

# HIGHER EDUCATION

UNIVERSITY TOWN. With the decline of Kalamazoo's various industries, colleges and the university have become an increasingly important part of the city's economic and social makeup. The photos in this chapter provide a brief examination of some of these institutions. This photograph from the early 1930s shows the porticos of Western Michigan University's East Hall. (Western Michigan University Archives and Regional History Collections.)

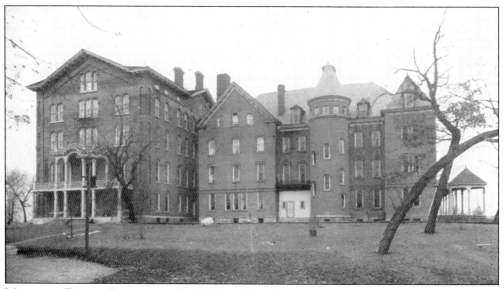

**MICHIGAN FEMALE SEMINARY.** The Michigan Female Seminary was one of the more interesting of Kalamazoo's early educational institutions. The seminary, opened in 1856, offered classes in all subjects to young women, including exercise and domestic duties. However, the school was never a financial success and it closed in 1907.

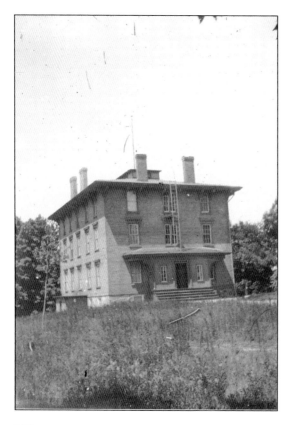

**KALAMAZOO COLLEGE.** Kalamazoo's oldest educational institution, and the State's oldest private college, Kalamazoo College opened in 1833. Today it is one of the most respected liberal arts colleges in the nation. This photograph shows the school's first building, "Upper College," on the present campus. (Western Michigan University Archives and Regional History Collections.)

**HILLTOP VIEW.** This view from Prospect Hill looks down at Kalamazoo College's second building. "Lower Hall" was at the intersection of South Street and Oakland Drive. Apartments now occupy the site.

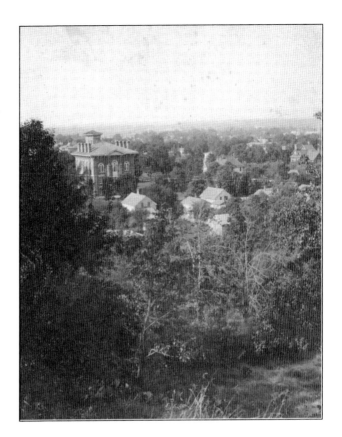

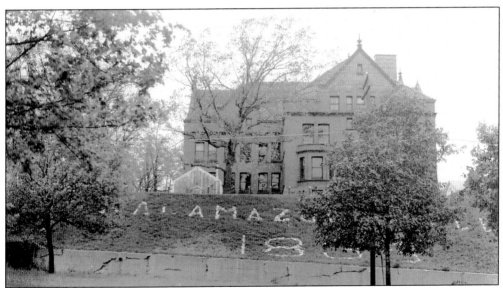

**KALAMAZOO COLLEGE.** This picture from around 1930 looks up at the hill where the present Kalamazoo College campus is located. Bowen Hall is visible above a stone message announcing the school's founding date.

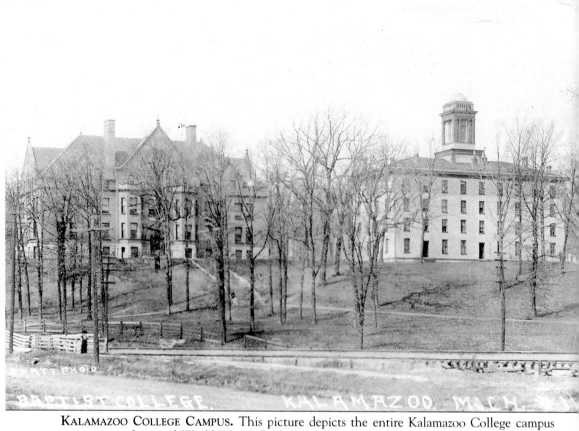

**KALAMAZOO COLLEGE CAMPUS.** This picture depicts the entire Kalamazoo College campus as it appeared around World War I. Both Bowen Hall and "Upper College" are visible. A construction boom would soon add several new buildings in the 1920s and 1930s.

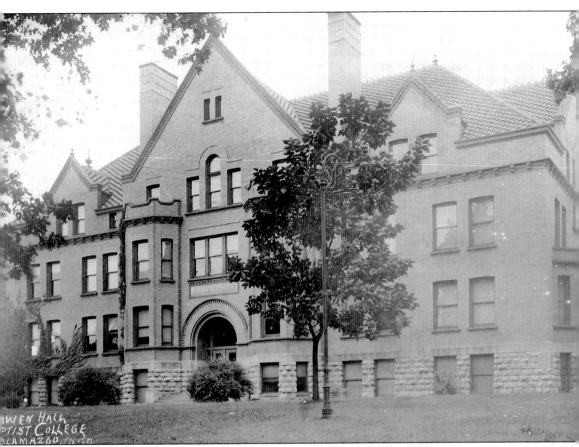

**BOWEN HALL.** Bowen Hall was built in 1902 as Kalamazoo College's primary building. It housed a number of classrooms and an auditorium. However, by the 1960s, the school needed more space for newer facilities, and in 1969 the building was torn down to expand the present Hicks Center.

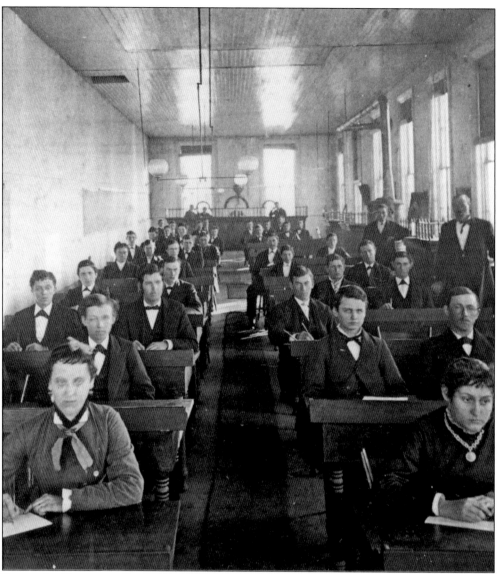

**PARSON'S BUSINESS COLLEGE.** The forerunner to today's Davenport College, Parson's Business College opened in 1869 to teach business administration, accounting, salesmanship, and advertising. The school was housed in several downtown buildings over the years. This interior view is evidently from one such building. (Western Michigan University Archives and Regional History Collections.)

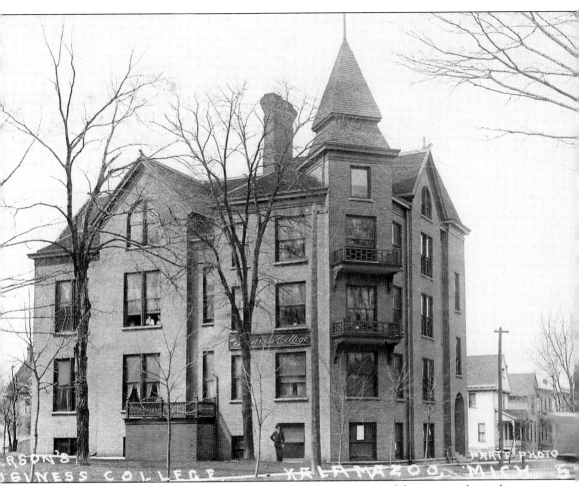

**PARSON'S.** In 1902 Parson's constructed its own building just west of downtown, shown here. The unusual brick building served their purposes until 1946. The college moved on to become Davenport. The 1902 building was leveled in 1952.

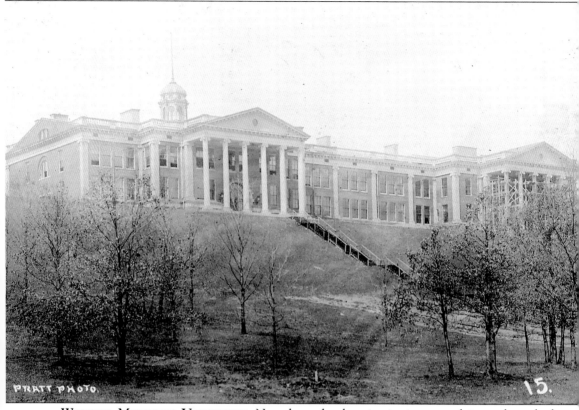

**WESTERN MICHIGAN UNIVERSITY.** No other school or institution can claim to have had as large an impact on Kalamazoo than Western Michigan University. Established in 1903 as Western State Normal School, Western has steadily developed from a small teachers' college into one of the state's largest universities. The school's first building, East Hall, is shown here. The college opened in 1905 and this picture is from 1908. The scaffolding is still visible on the portico of the 1908 gymnasium addition.

**PROSPECT HILL.** A hilltop southwest of downtown known as Prospect Hill was the site selected for the university. In those days, it was a largely undeveloped area, as evidenced here. Noted landscape architect Frederick Law Olmstead created a stunning landscape for a series of proposed buildings. Over the years, today's Vine Neighborhood would develop below the hill seen here.

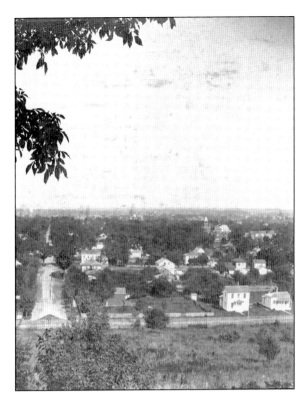

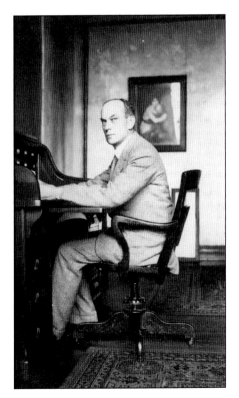

**PRESIDENT WALDO.** The man chosen to run the new Normal School was Dwight B. Waldo. Waldo personally assembled a remarkable faculty and kept the school operating for over 30 years. He would later be buried below his office in East Hall. (Western Michigan University Archives and Regional History Collections.)

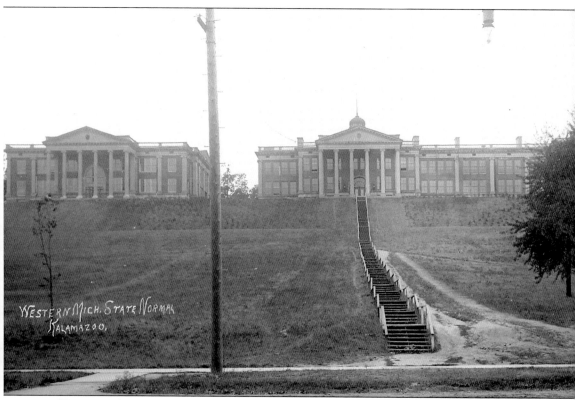

TRAINING SCHOOL. By 1910 East Hall was completed with the addition of the training school seen here on the left. Since at that time it was difficult for student teachers to get experience in the classrooms of surrounding communities, a private elementary and high school was created on the college campus. This addition gave East Hall three column porticos and earned it Will Rogers' description as the "Acropolis of Kalamazoo."

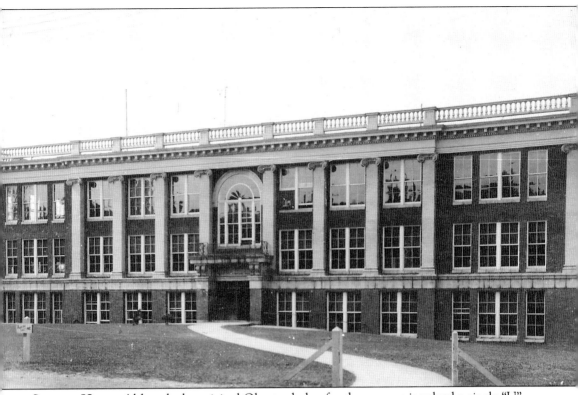

**SCIENCE HALL.** Although the original Olmstead plan for the campus involved a single "U"-shaped layout, when the science hall was constructed in 1915, it was built as its own separate building. Now known as West Hall, it was designed by E.W. Arnold who had designed East Hall. Thus the two structures share many of the same architectural features.

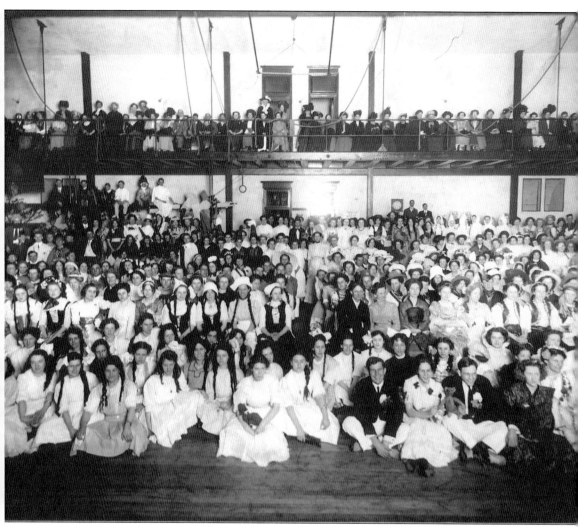

EAST HALL GYMNASIUM. The north end of East Hall, built in 1908, contained all of the school's athletic facilities. These included the gymnasium, pictured here, and an indoor pool. Today these areas house the Western Michigan University Archives and Regional History Collections. (Western Michigan University Archives and Regional History Collections.)

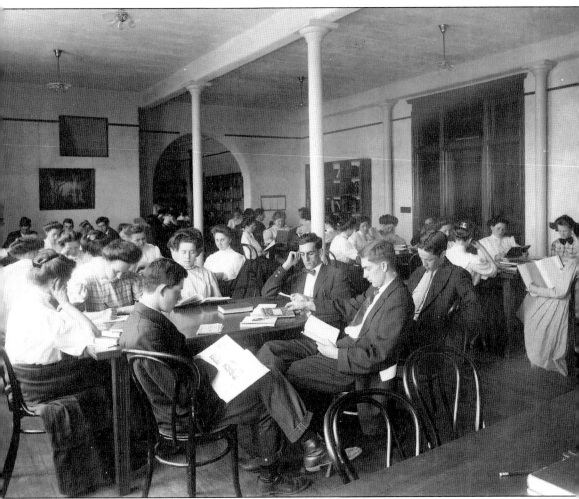

**EAST HALL LIBRARY.** East Hall was originally built to service all of Western's needs in 1904, which included a small library. However, by the 1920s, it was clear that more space was needed. That certainly appears to be the case in this photograph. (Western Michigan University Archives and Regional History Collections.)

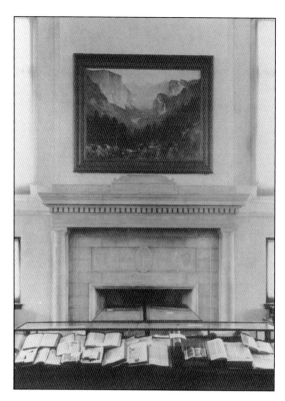

**A NEW SHOWPLACE.** The overcrowding of the library was solved in 1924 when a new separate library building opened. The library was the most elaborate building on campus, complete with a three-story-high vaulted reading room. The interior was decorated with several works of art donated by industrialist A.M. Todd. (Western Michigan University Archives and Regional History Collections.)

**THE STEPS OF KNOWLEDGE.** The location of the classroom buildings on the top of Prospect Hill, and the location of much of the available housing at the bottom, made the daily hike to classes tiresome. A student is seen here in the late 1920s descending with East Hall in the background. (Western Michigan University Archives and Regional History Collections.)

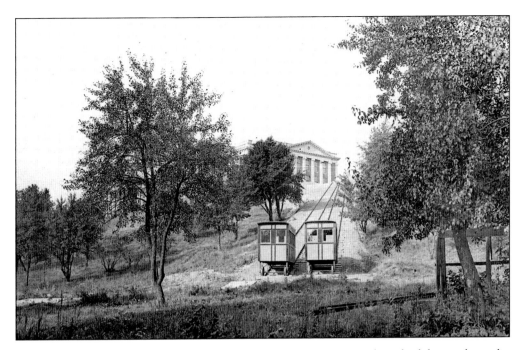

NORMAL RAILROAD. The Normal Railroad offered a more practical method for reaching the top of Prospect Hill. This system consisted of an unusual dual cable car that lifted students up the northeast corner of the hill. The railway operated until 1948. (Western Michigan University Archives and Regional History Collections.)

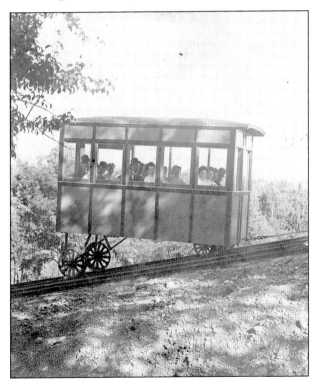

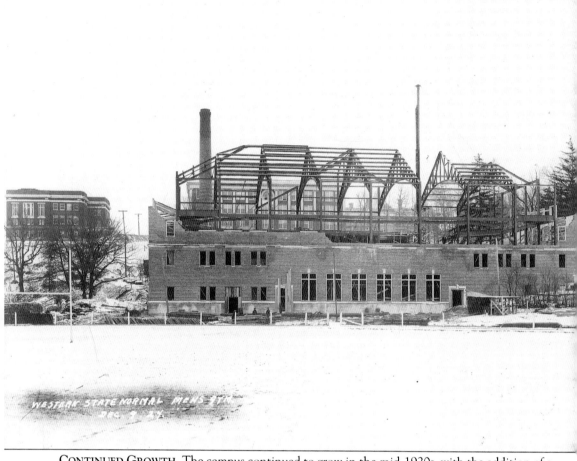

**CONTINUED GROWTH.** The campus continued to grow in the mid-1920s, with the addition of a manual arts building and Oakland Gymnasium. This picture shows Oakland Gymnasium under construction in the winter of 1924. The steel supports for the elevated running track are visible. Behind the frame, the rest of campus can be seen. (Western Michigan University Archives and Regional History Collections.)

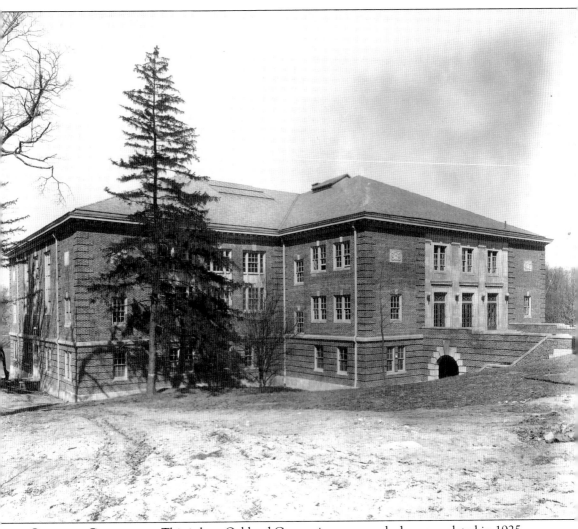

**OAKLAND GYMNASIUM.** This is how Oakland Gymnasium appeared when completed in 1925. In addition to the basketball court, the building contained a running track, indoor baseball practice facility, and locker rooms. A changing campus eventually saw most of its original uses move to other facilities. ROTC later used the gym before it was demolished for the Seeyle Center in 2001. The façade seen here has been retained and incorporated into the new facility. (Western Michigan University Archives and Regional History Collections.)

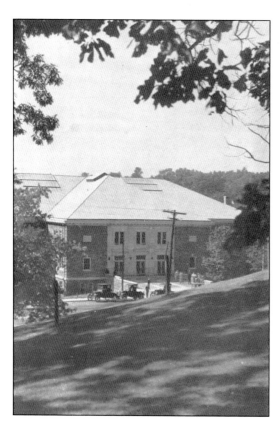

PICTURESQUE SETTING. The wooded hilltop setting for Western made it a visually stunning stage for learning. This picture looks towards Oakland Gymnasium and Oakland Drive from the Science Hall. With the exception of the Seeyle Center, the view is much the same today. (Western Michigan University Archives and Regional History Collections.)

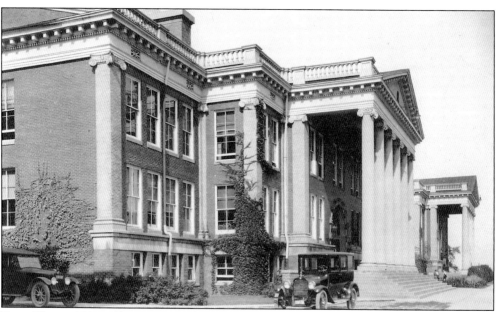

EAST HALL, 1920S. Drivers are parking wherever they can in this mid-1920s shot. With a growing student body and the increased use of automobiles, Western faced a mounting parking problem. The current lack of parking on East Campus has made it difficult to find uses for the campus's faculties.

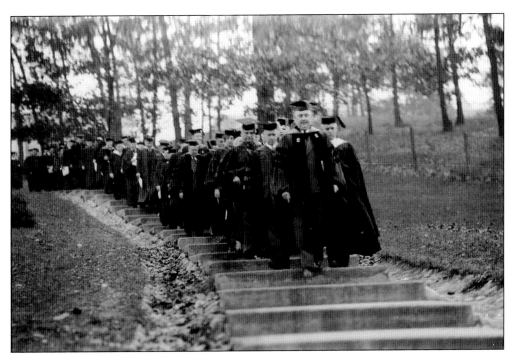

INAUGURATION. The inauguration of a new president is always the occasion for ceremony. In the above picture, a procession of robe-wearing faculty heads down Prospect Hill for President Sangren's inauguration in 1939. Below we see President Miller being sworn in in 1965. (Western Michigan University Archives and Regional History Collections.)

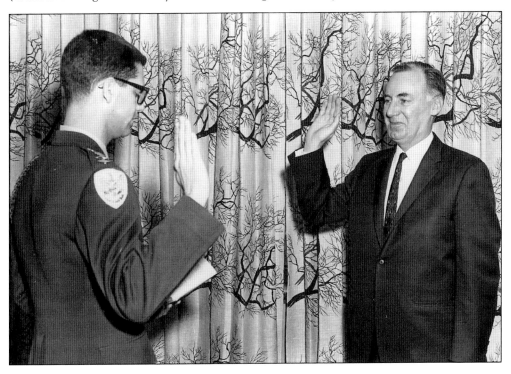

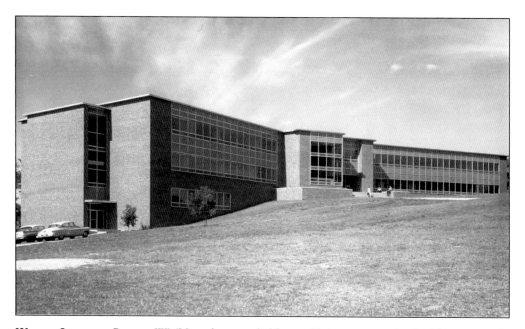

WALDO LIBRARY. Present WMU students probably wouldn't recognize this building as Waldo Library. Opened in 1957 to replace the cramped old facility, Waldo offered many conveniences, such as open stacks and card catalogs. Today, the building has been considerably altered and the card catalogs have given way to electronic versions. (Western Michigan University Archives and Regional History Collections.)

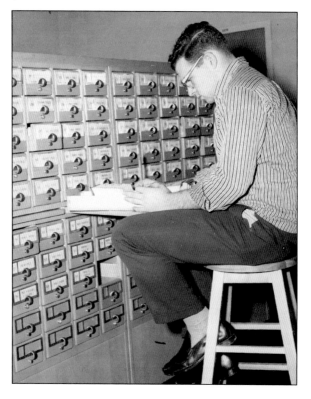

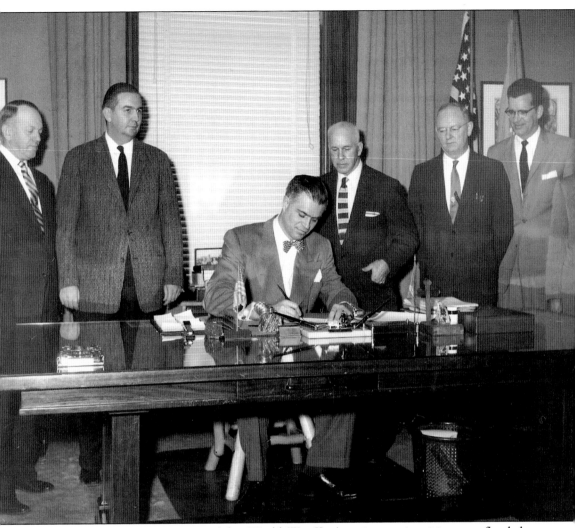

**FROM COLLEGE TO UNIVERSITY.** After World War II, American universities were flooded with new students. Western was no exception and within a short time, began to expand upon its traditional teachers' college offerings. With the addition of several new colleges, Michigan Governor Williams is shown here signing university status to the school in 1957. (Western Michigan University Archives and Regional History Collections.)

**WEST CAMPUS.** Following World War II, WMU rapidly expanded physically with the construction of a new campus to the west of the old campus. The buildings constructed to house the university's growing programs and student population in the 1950s and 1960s were typical for their day. This 1967 photo shows Brown Hall and Sprau Tower. (Western Michigan University Archives and Regional History Collections.)

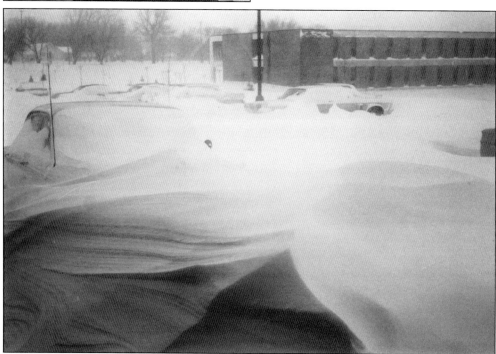

**SNOWDRIFTS.** On January 26, 1967, Kalamazoo was buried in a particularly bad snowstorm. This photo shows just how deep the drifts became near Kohrman Hall on WMU's West Campus. (Western Michigan University Archives and Regional History Collections.)

**MARTIN LUTHER KING JR. ADDRESSES WMU.** WMU has provided Kalamazoo with a number of cultural events and guest speakers over the years. In 1963 Dr. Martin Luther King Jr. came to town to address a packed Reed Field House. (Western Michigan University Archives and Regional History Collections.)

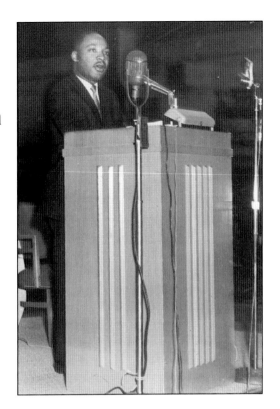

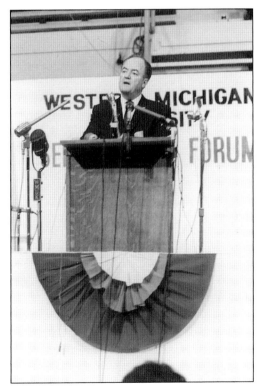

**HUBERT HUMPHREY.** Besides King, WMU has brought a number of nationally-known speakers and political leaders. Among them was presidential hopeful Hubert Humphrey in 1964. (Western Michigan University Archives and Regional History Collections.)

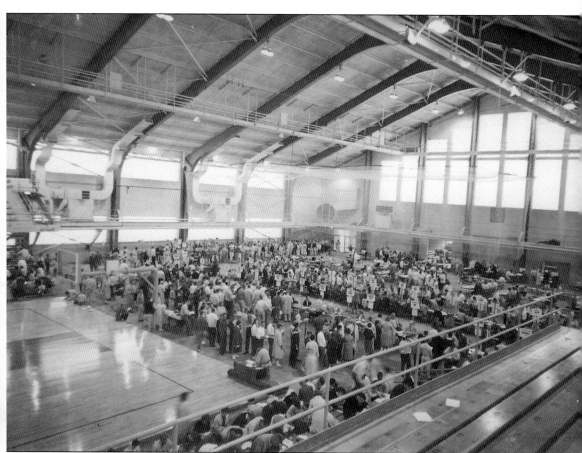

**THE HORRORS OF REGISTRATION.** Present-day students should be thankful for the convenience of telephone and online class registration. This picture, taken in Reed Field House, shows the old way of doing things, which entailed spending hours filling out a schedule manually. (Western Michigan University Archives and Regional History Collections.)

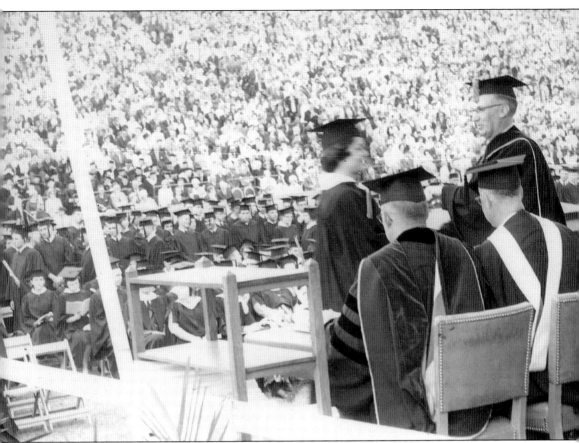

**THE JOY OF COMMENCEMENT.** Hopefully, the trials of classes would prove worthwhile on graduation day. This photograph shows President Miller conferring degrees at the 1964 commencement ceremony. Athletic facilities such as Reed Field House are often the location for these events, due to the number of graduates. (Western Michigan University Archives and Regional History Collections.)

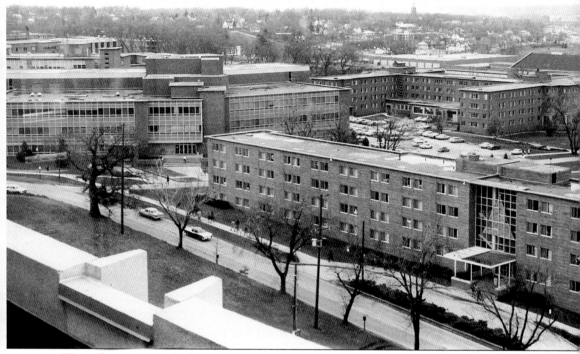

**WEST CAMPUS.** By the late 1960s, most of today's West Campus was built up. This rooftop view looks eastward towards the Waldo Library, center, and Moore Hall, on the lower right. If you look closely, you can see the bell tower of Kalamazoo College in the distance. (Western Michigan University Archives and Regional History Collections.)

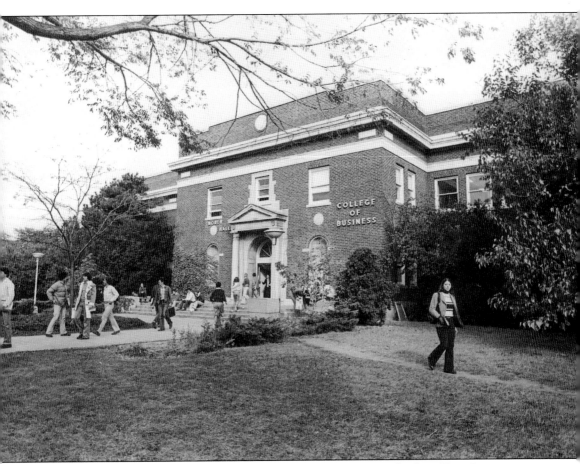

**NORTH HALL.** We conclude our examination of Western by going back to East Campus in 1979. Most of the University's programs have moved to the West Campus. However, the College of Business would remain in North Hall, the former library, until 1989. East Campus currently houses a number of offices, art students' studios, and the University Archives. (Western Michigan University Archives and Regional History Collections.)

# BIBLIOGRAPHY

Dunbar, Willis, *Kalamazoo and How it Grew*. Western Michigan University, Kalamazoo, 1959.

Henehan, Brendan. *Walking Through Time*. Kalamazoo Historical Commission, Kalamazoo, 1981.

*History of Kalamazoo County, Michigan*. Everts & Abbott, Philadelphia, 1880.

Houghton, Lynn and Pamela Hall O'Connor. *Kalamazoo Lost and Found*. Kalamazoo: Kalamazoo Historic Preservation Commission, 2001

Hosler, Wilbert. "Development of the Paper Industry in Michigan." Term Paper for *Michigan History Magazine*. WMU, 1935.

*Looking Back: A Pictorial History of Kalamazoo*. Heritage House Publishing, Marceline. 1994.

Massie, Larry and Peter Schmitt. *Kalamazoo: The Place Behind the Products*. Windsor Publications. 1981.

Mayer, Elizabeth. *Yes, There were Germans in Kalamazoo*. The Kalamazoo County Historical Society, Kalamazoo, 1979.

Payne, Will. "The Forehanded Man." *Saturday Evening Post* 13 November 1913: 1-5.

Schmitt, Peter. *Kalamazoo: Nineteenth-Century Homes in a Midwestern Village*. Kalamazoo Historical Commission, Kalamazoo, 1976.

Sharpsteen, Harold. *The Life of John Henry Burke*. Ihling Bros. Everard Co., Kalamazoo, 1948.